# HOW TO DRAW
# CARICATURES

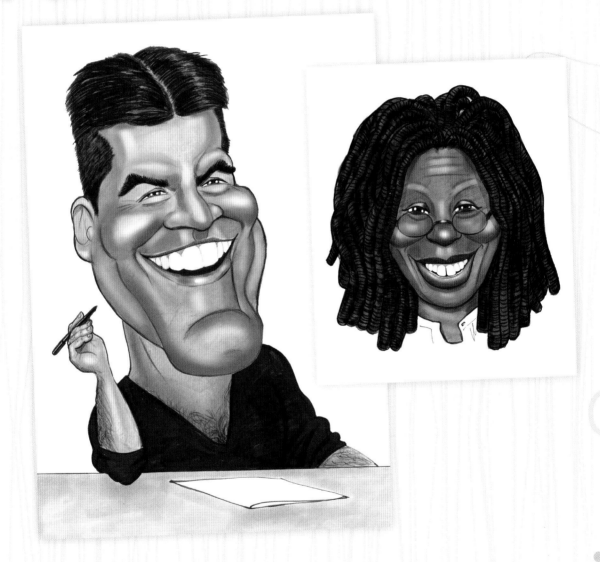

## BY MARTIN POPE

ILLINOIS PRAIRIE DISTRICT LIBRARY

Walter Foster

ILLINOIS PRAIRIE DPL

A66602 189558

D1026651

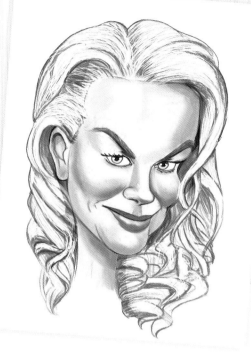

Copyright © 2013 Arcturus Publishing Limited.

Sketches on pages 54, 58–59, and 106 by Claire Pope.

Tools and Materials artwork on pages 6-7, 109, 112-113, and 116
© Walter Foster Publishing.

This book has been produced to aid the aspiring artist.
Reproduction of the work for study or finished art is permissible.
Any art produced or photomechanically reproduced from this
publication for commercial purposes is forbidden without
written consent from the publisher, Walter Foster Publishing, Inc.

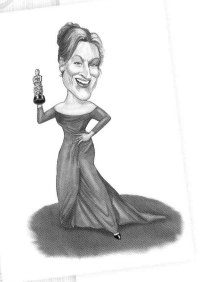

www.walterfoster.com
Walter Foster Publishing, Inc.
3 Wrigley, Suite A
Irvine, CA 92618

10 9 8 7 6 5 4 3 2 1

# Contents

# Introduction

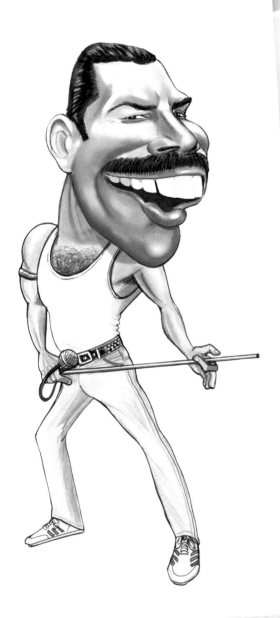

## WHAT IS A CARICATURE AND CAN ANYONE DO IT?

The word "caricature" essentially means "loaded portrait"—in other words, it's a portrait that focuses on the subject's unique facial features and loads, or exaggerates, them. The degree of exaggeration is a matter of choice; every caricaturist has their own style, some pushing things to extremes and others being very subtle.

Can anyone learn to caricature? I believe so, but if you feel you have little drawing ability I recommend you read a good book on basic drawing skills before attempting the techniques detailed here. Drawn well, caricatures are not only entertaining to others, but they are also hugely rewarding to you as their creator. They are great fun to do and are an ideal creative outlet for budding and experienced artists alike.

## WHY CARICATURE CELEBRITIES?

While drawing a caricature of a close friend or relative is enjoyable and provides good practice, it won't get your artistic skill noticed on a wide scale. For this, you need to caricature someone well-known to the public. Drawing caricatures of famous people such as royalty, heads of state, and government officials has been popular for centuries—indeed, there is even evidence of a politician caricatured as wall graffiti in the ancient Roman city of Pompeii, destroyed by the eruption of Vesuvius in AD79. What is new, however, is the modern cult of celebrity that feeds off television, movies, magazines, and the Internet. The benefit for caricaturists is that there are now more "celebs" in the public eye than ever before.

## WHAT WILL YOU LEARN?

In this book, I want to teach you the building blocks of caricaturing, from the basic layout of features on the human head, to looking at what makes each person different and how to exaggerate to best effect. Then we'll move on to looking at full-figure caricatures, props, extreme exaggeration, and the various tools you can use to enhance your final piece. Throughout the book are examples of my own caricatures for you to follow and—hopefully—be inspired by!

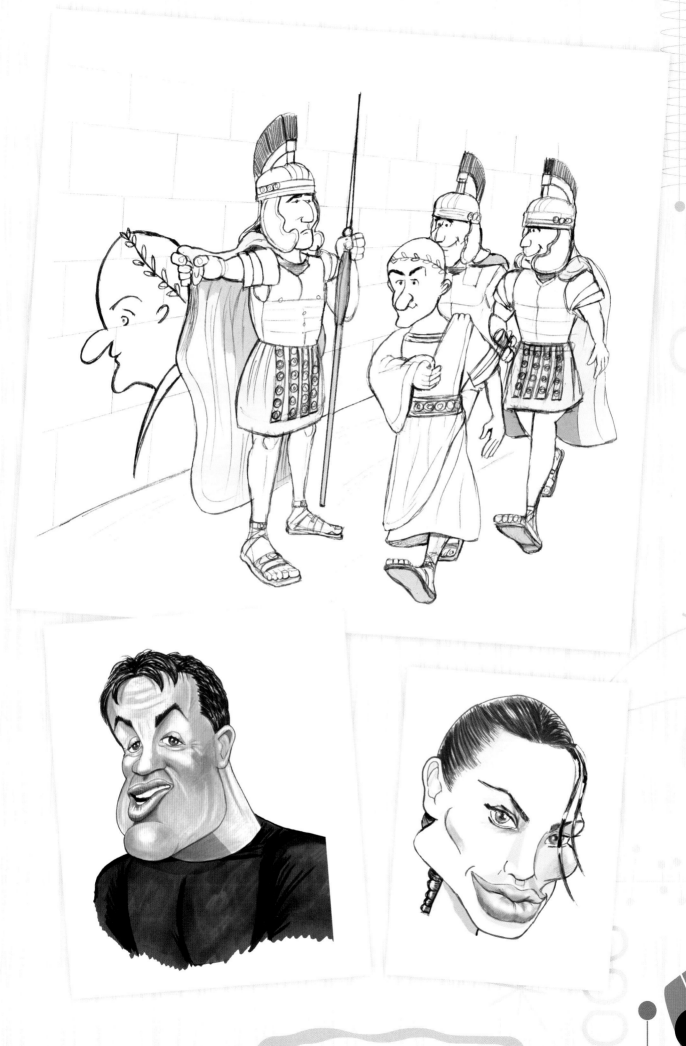

# Tools & Materials

The range of materials available to artists can often be overwhelming. Here I recommend just a few that I find most useful for my work. As you learn and experiment with caricaturing you may discover other materials that you enjoy working with, but these will get you off to a good start.

First you'll need something to draw with, and a pencil is a good starting point. Pencils come in different lead grades from 6H (the hardest) to 6B (the softest), with HB in the middle. I use HB for all my pencil work. Another option is a mechanical pencil, which never needs sharpening and takes refill leads available in various grades.

The next consideration is your drawing surface. For sketching out your initial ideas, 8½" x 11" 16-lb. layout paper is ideal as its semi-transparent quality allows you to lay one sheet over another to trace anything worth keeping from your previous sketches.

For final artwork I like to use 8½" x 11" 58-lb. Bristol cardstock. Its thickness and extra-smooth surface make it suitable for most mediums and is particularly good for ink and pencil work.

When it comes to tracing your initial drawings onto fine-quality paper or Bristol board a light box will come in handy.

You will need a good-quality soft eraser to remove any unwanted pencil lines.

Black fineliners are ideal for intricate work. You can buy these in various sizes; I use anything from 0.2mm to 0.5mm.

This pen is versatile—it has a brush tip at one end and, at the other, a tip similar to a fineliner but thicker.

Water-soluble artists' painting crayons are ideal for blending to create realistic skin tones.

Dual-tipped marker pens are very useful. One end is pointed for more intricate work while the other is flat, suitable for filling in blocks of color or shading. Another bonus with most marker pens is that they can be refilled from ink bottles bought separately.

Applied with a fine brush, white gouache paint is ideal for adding highlights to your finished artwork.

Colored pencils are great for adding intricate color work.

# Observation & Recognition

## THE RELATIONSHIP OF SHAPES

In a nutshell, the key to caricaturing is observation. Most of us observe faces continuously throughout the day without giving it a second thought. How else would we recognize people when we meet them or know how to react to facial expressions if we weren't able to process the information we see? To draw caricatures, we have to be aware of the information being received and fast-track it into our conscious rather than let it take the normal route to our subconscious.

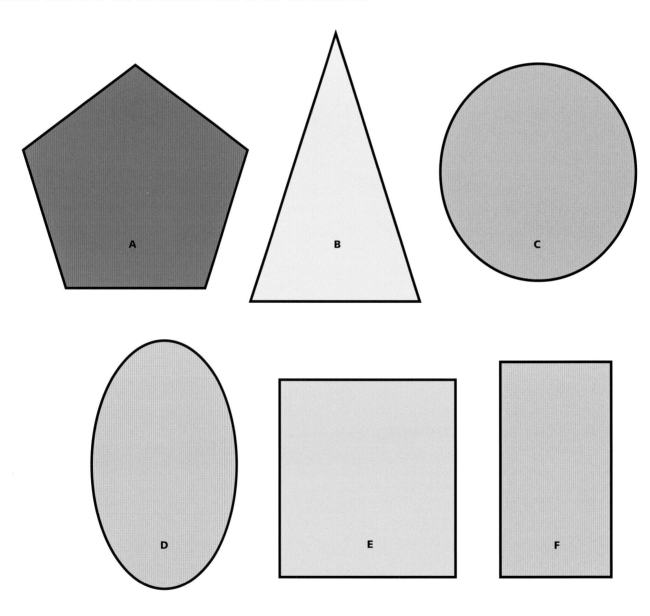

**Figure 1** Take a look at these six shapes. If you were asked to identify them, you would probably say shape A is a pentagon, shape B a triangle, shape C a circle, shape D an oval, shape E a square, and shape F an oblong. Indeed, most people would give those answers unless they had an unusually good eye for measurement.

**Figure 2** If you take a look at the three shapes shown here, you will notice that the one in the middle stands out from the other two. This is because, unlike the shape either side, it's not a perfect circle but an oval. It's also the same shape that's represented by the letter C on the opposite page.

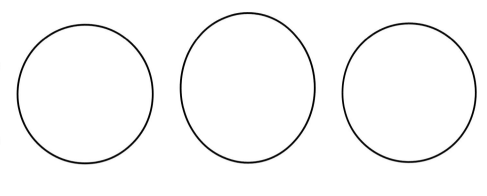

**Figure 3** Again the shape in the middle stands out from the other two—it's not a perfect square but an oblong. It's also the shape that's represented by the letter E on the opposite page.

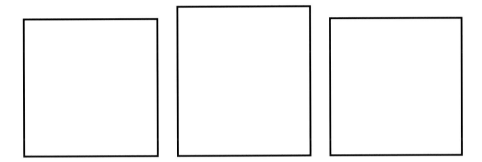

My purpose in showing these shapes is to illustrate that without having a template to use for comparison it is difficult to know if we have our dimensions correct. The whole essence of producing a credible caricature is being able to spot what is different and unique about the face we intend to caricature.

## FACE RECOGNITION

Unlike a lot of the creatures on this planet, we human beings have facial characteristics quite different from one another. Fortunately for us, we also possess the ability to recognize these features after they are subconsciously stored in our memory.

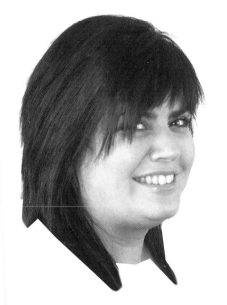

When you stop to think about it, it's an amazing accomplishment that our minds are able to record the precise layout of an individual's features so that when we next see him or her we can identify that person out of the hundreds or maybe even thousands of faces that we have in our memory bank. More amazing still is that if we come across the same face some 20 years later we may recognize it, even though the subject's hair may have gone gray, receded, or disappeared altogether. They may also have lost or gained weight and acquired an extra chin or two, and they will certainly have developed some wrinkles, but, with a little effort, we can usually identify them purely by recalling the layout of their eyes, nose, and mouth.

Just how we manage to accomplish this I'm not entirely sure. However, for the purpose of drawing caricatures all you need to know is that most of us possess this incredible ability. The next step is to fine-tune this natural gift and take more notice of it.

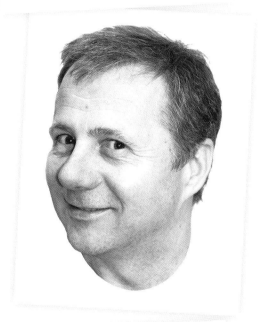

To be able to caricature successfully, you must develop your capacity for face recognition further in order to identify what is unique about each face you draw. Step by step throughout this book, you will discover how to identify what makes people's facial features individual in size, shape, and layout, so that you can then exaggerate them effectively.

Take a look at the faces displayed on these two pages. Look at each one individually for about 10 seconds. If you were shown them again you would probably know you had seen them before, which means you have subconsciously stored the relevant information to be able to recognize them. The key is accessing this information and getting it down on paper.

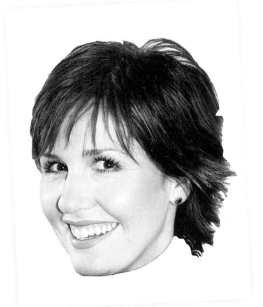

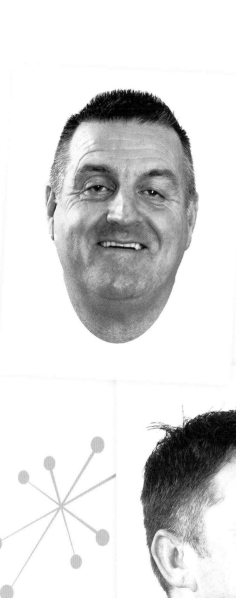
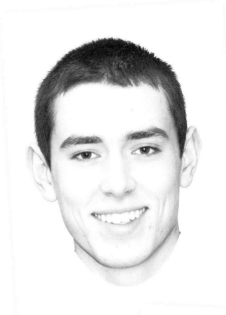

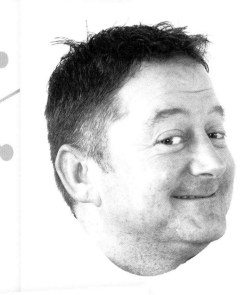
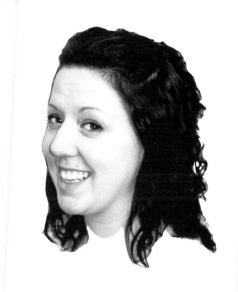
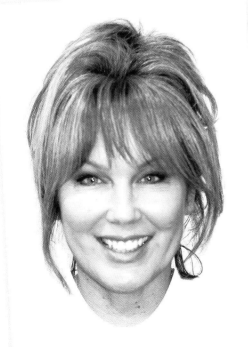
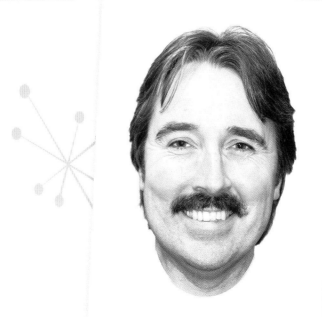

## PUTTING THE PIECES TOGETHER

The more often we see a particular face, the stronger our recollection of it becomes. In the case of celebrities, we may encounter their image several times a day in print and on a television or computer screen.

Take a look at the selection of celebrity caricatures on these pages. The reason you can recognize who they are is that not only are they different from each other in age, gender, and skin color, but each face is also unique. Therefore, out of all the hundreds or maybe thousands of other faces you have stored in your memory you are able to identify these few. Observation and face recognition are really part of the same process; we observe what is unique and different about a face, which then enables us to recognize it.

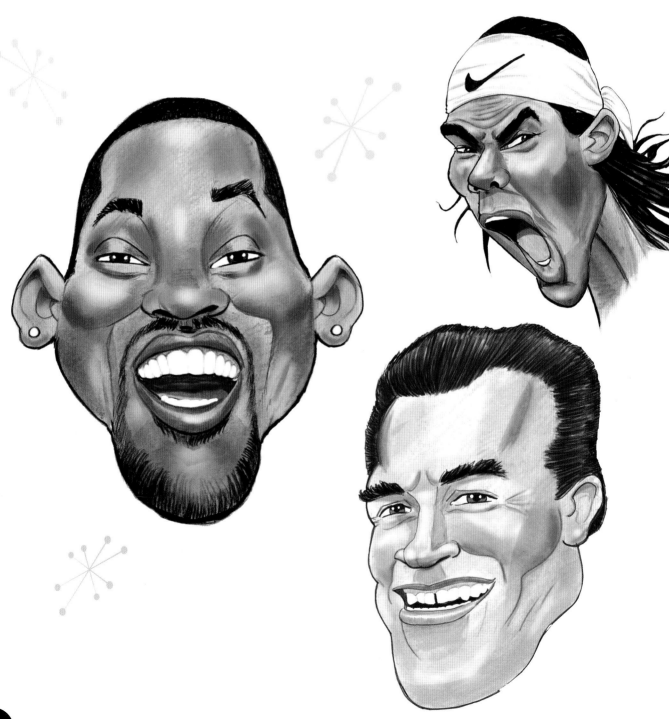

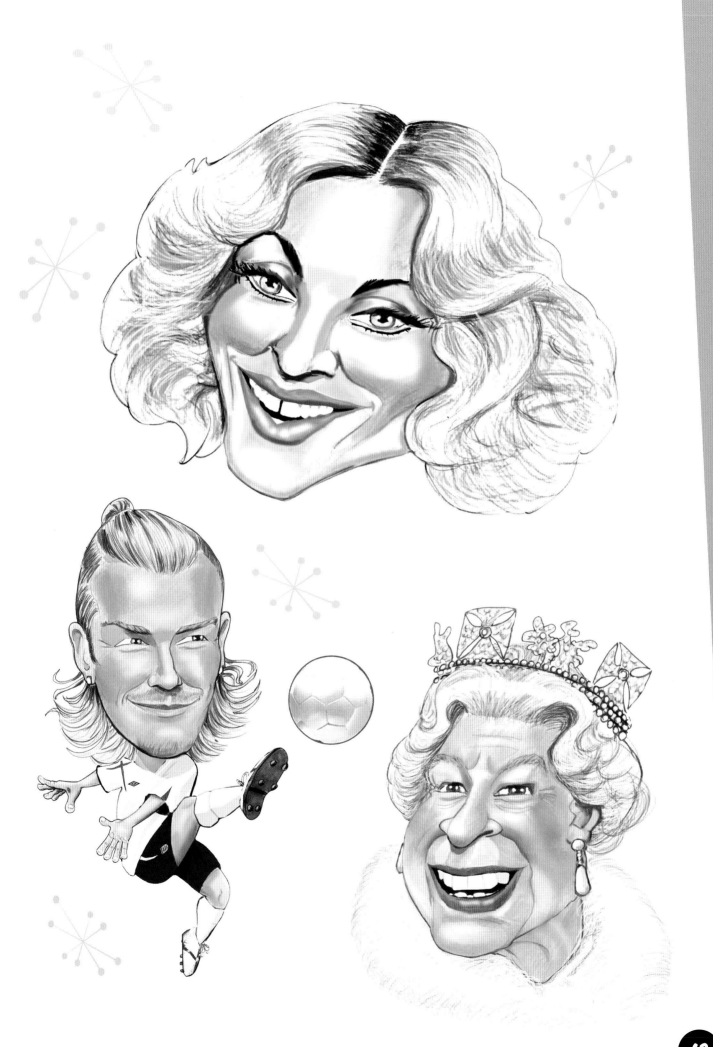

# The Face Base

Once you have consciously taken notice of the information you have gained about someone's face so you can transfer it on to paper, the next step is to establish what's different about the information in comparison to that of another face. At this stage it's important that the face you compare it to has an average set of features with an average face layout. To help provide you with a guideline to work from, I have created a face that is a mixture of everyone. It represents no particular race, nor is it male or female—it's an invention and it's pretty nondescript, which is perfect for what we need. It is only right we should put a name to a face, so let's call this the "Face Base." The Face Base would be a caricaturist's nightmare, as it has very little character.

For example, if you were asked the following five questions about the Face Base:

• What sort of a mouth does it have?
• What sort of nose?
• What sort of eyes?
• What sort of chin?
• What sort of ears?

Your answers to all five would most probably be either "just normal" or "average"—not very useful if you were an eye witness describing the prime suspect of a crime.

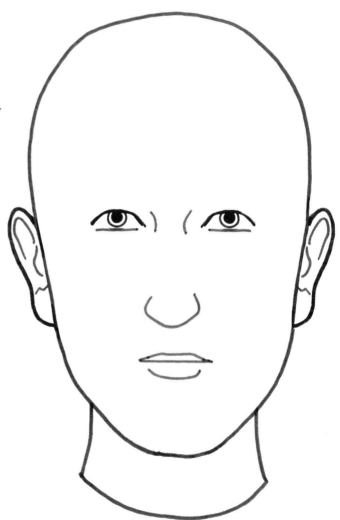

If, on the other hand, you were asked to describe the face shown on the right, it would be a lot easier:

• What sort of a mouth does he have? Small and down-turned.
• What sort of nose? Long, wide, and pointed.
• What sort of eyes? Set close together, one slightly higher than the other.
• What sort of a chin? Small.
• What sort of ears? Large and sticking-out.

As you can see, with this face there is a lot more to work with. It has character.

Even with the addition of eyebrows, cheekbones, and some shading (below), the Face Base would still be hard to describe. But although it is lacking in facial character, it serves as a valuable point of reference to work from.

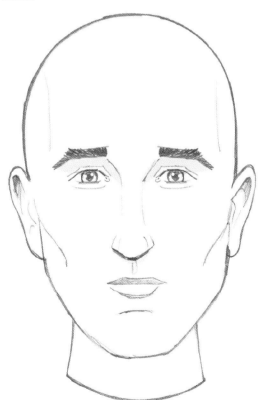

## THE FACE BASE IN PROFILE

Make a point of viewing any subject you decide to caricature from the side. There is valuable information to be gained from looking at them from this angle.

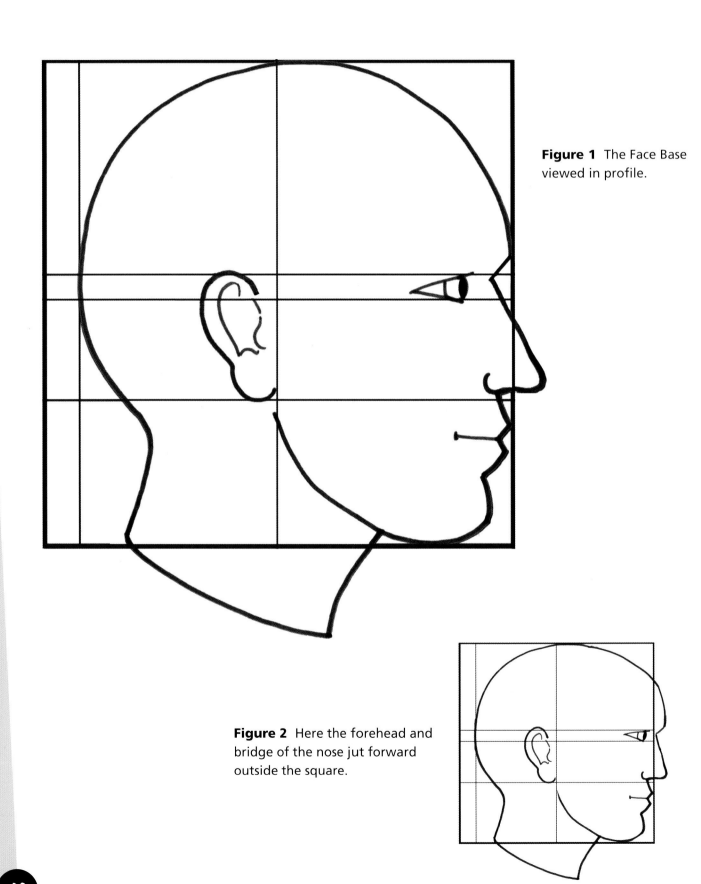

**Figure 1** The Face Base viewed in profile.

**Figure 2** Here the forehead and bridge of the nose jut forward outside the square.

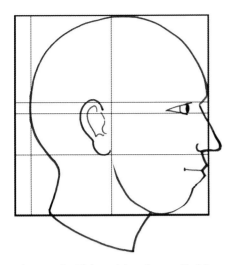

**Figure 3** This subject's small chin almost disappears into the neck.

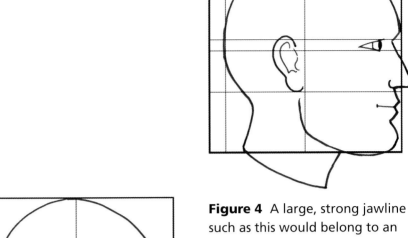

**Figure 4** A large, strong jawline such as this would belong to an adult male.

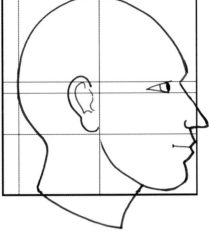

**Figure 5** Here the forehead and bridge of the nose slope back away into the square. The nose is also longer.

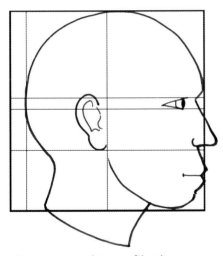

**Figure 6** In this profile the gap between the nose and the mouth is larger and the chin is smaller.

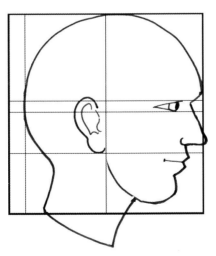

**Figure 7** From the bridge of the nose the whole face slopes down and inwards.

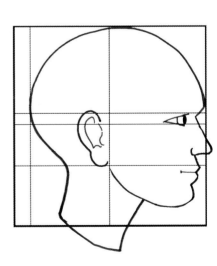

**Figure 8** The jaw, chin, and skull are shorter; the nose is slightly smaller and the neck is thinner. This profile would belong to a child or petite woman.

# Proportions of the Head

To be able to define what is unique about the person you choose to caricature, it helps to have an idea of the basic shape, layout, and measurements of an average human head so that you have something to use as a comparison.

**A** This line divides the head in half horizontally. When placing the eyes along this line, imagine that the head is divided into five sections, each the width of an eye.

**B** The tops of the nose, eyes, and ears are in line with each other.

**C** The bases of the nose and ears are in line with each other.

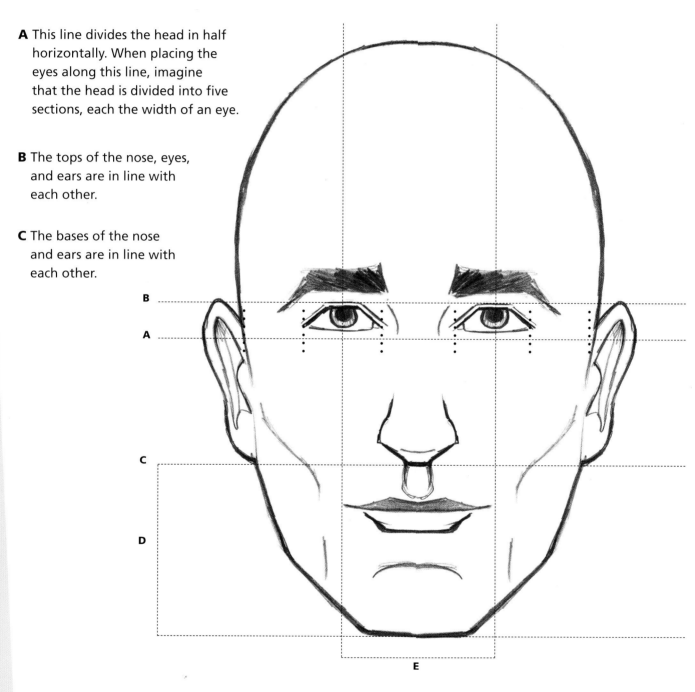

**D** The distance from the bottom of the chin to the base of the nose measures about 30 percent of the total length of the head.

**E** The corners of the mouth are often in line with the center of the pupils.

18

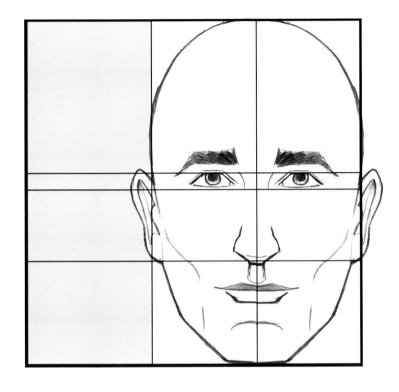

Here I have placed the same head in a square grid. When viewed face on, the head fills approximately 70 percent of the square.

With another head in the same square you can immediately see the differences in proportion. This head is wider, taking up a larger percentage of the square. The horizontal guidelines show that the eyes are set slightly higher and the nose is considerably shorter, increasing the gap between the nose and mouth.

I am not suggesting you lay this grid over every caricature you attempt to draw. The idea of this exercise is merely to focus your attention on identifying the differences between one face and another by using the average face as a guideline.

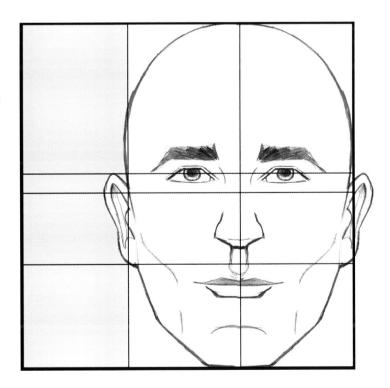

# PROPORTIONS OF THE HEAD IN PROFILE

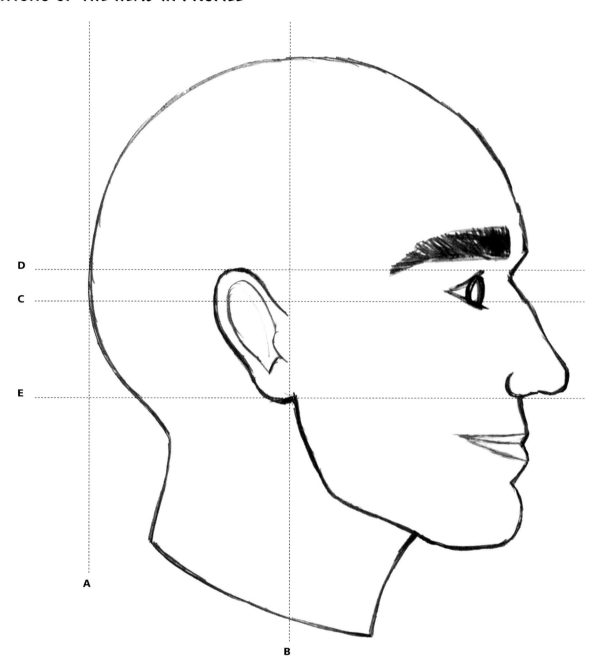

**A** This line illustrates where the back of the head finishes in relationship to the square. As you can see, it falls just short of filling 95 percent of the square. However, because the difference is so small, it is still worth using a square as a guideline for the depth of the head in profile—just remember to draw slightly within it.

**B** This line divides the square in half vertically. The front part of the head to the right of the earlobe comfortably fills 50 percent of the square. The ear is set behind the centerline, on the left side of the square.

**C** This line divides the head in half horizontally and, as with the full-face illustration, runs just below the eye.

**D** The tops of the eyes, nose, and ears are in line with each other.

**E** The bases of the nose and ears are in line with each other.

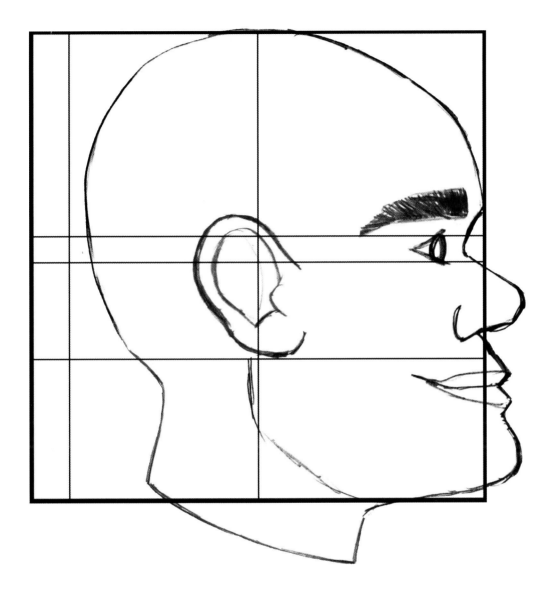

Whichever angle you decide to caricature from, it always pays to view them in profile as you will gain valuable information about the size and layout of their features that will not be so apparent from other angles. Seen face-on, the character below would no doubt look a little different from the one on the opposite page, but from this angle the variation in features jumps off the page.

- The forehead slopes back steeply and the overall head shape takes up less of the square than the average head opposite.

- The ear is larger, taking up space to the right of the vertical center line and also rising way above the average guideline for the top of the ears.

- The nose is upturned and short. It is positioned a fair way above the guideline for the base of the nose.

- The mouth and chin protrude right outside the square.

# Facial Features

Identifying the layout of facial features as a group is just as important as observing their individual shape and size. As a unit, the features form characteristic patterns that help us to distinguish between one face and another.

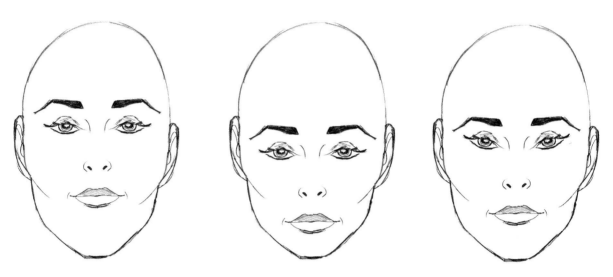

Note how the three faces above seem to have different expressions: the one on the left looks confident and haughty, the middle one looks a little sad, and that on the right appears more impassive. In reality, they have the same expression and their features are identical in size and shape. It is the fact that their features are laid out on different areas on the head that makes them appear quite dissimilar.

To simplify what we are looking at, it is possible to determine the differences between these faces by drawing just four small lines within a rectangle.

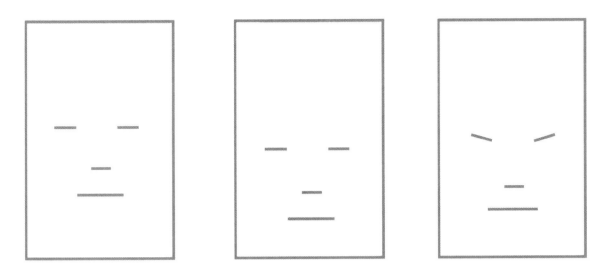

As you can see from the patterns above, the lines on the left are positioned relatively high up in their rectangle, while those in the middle are much lower. Those on the right are also positioned fairly low and the two lines that represent the eyes slant down toward the center. Try to train your eye to see differences like these. The face layout is important—if you get it right, the rest will follow.

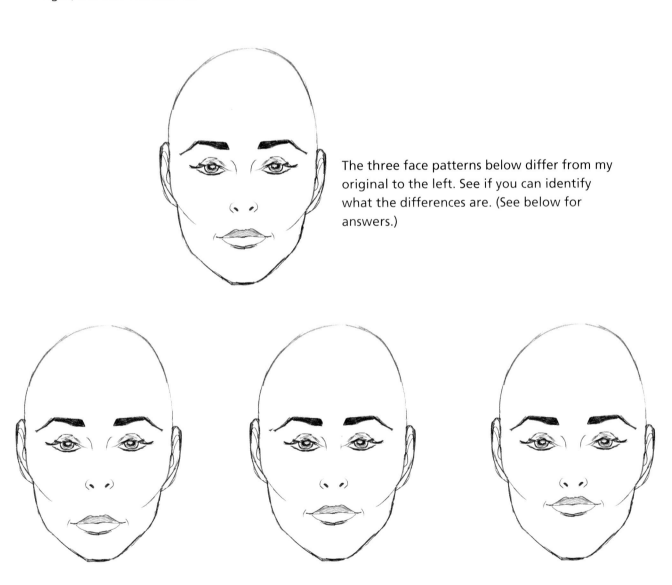

The three face patterns below differ from my original to the left. See if you can identify what the differences are. (See below for answers.)

Left: Mouth is lower down. Center: Eyes are closer together. Right: Mouth is positioned higher up.

## STUDY THE DIFFERENCES

This time we are looking not only at the face layout but also at the size and shape of individual features and of the head itself.

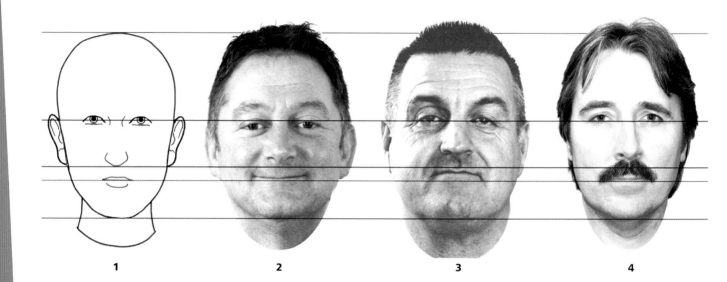

1        2        3        4

Here there are three real-life faces alongside the Face Base. All four heads fit between two horizontal lines across the top of the head and the base of the chin. There are also lines running through face 1's pupils, beneath the nose, and through the middle of the mouth. As you can see, the position of the features on each face differs considerably. The eyes of face 2 drop below the line, on face 3 they are dead center, and on face 4 they are above it. In the case of the nose, on face 2 it's slightly above, on face 3 considerably above, and on face 4 in between the two. The mouth on face 2 is almost dead center, on face 3 it is high, and on face 4 it is almost centered again.

Now that we have established what's different about these face layouts from a horizontal viewpoint, let's take a closer look at their individual facial features from the same viewpoint.

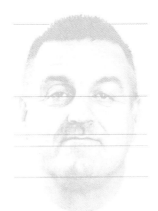

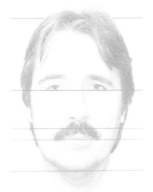

**Face 2.** This is a broader face than 1, with a much shorter nose. The ears drop far lower down in line with the mouth.

**Face 3.** Again this is a broader face than 1, with a very short nose. The ears are lower down and the chin is large.

**Face 4.** The head shape is similar to 1, but while the nose looks shorter it is not—remember the eyes are positioned higher, therefore the bridge of the nose is higher. If the eyes were in line with face 1, the nose would be about the same size, but it's bent over to one side.

## SEE WHAT YOU WANT TO SEE

To be able to record someone's face pattern you need to simplify what you are looking at. Practice seeing face patterns and try not to be distracted by the hairstyle, eye color, skin tone, and so on. All these things will be included later, but at this point see only the information that you need to and disregard the rest.

This is an example of how you can see two separate images within the same space. Do you see the old woman, the young one, or both? While this isn't a caricature, it makes the point that you can train your eye to see what you want to. The same goes for the face—train your eye to understand the layout first.

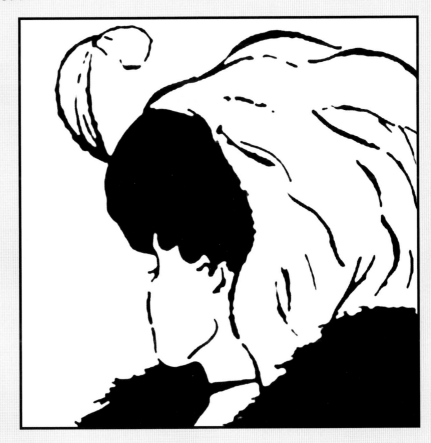

# Symmetrical & Asymmetrical Faces

This portrait, drawn by artist Claire Pope, is of the supermodel Naomi Campbell. With features perfectly aligned with one another, hers is a good example of a symmetrical face.

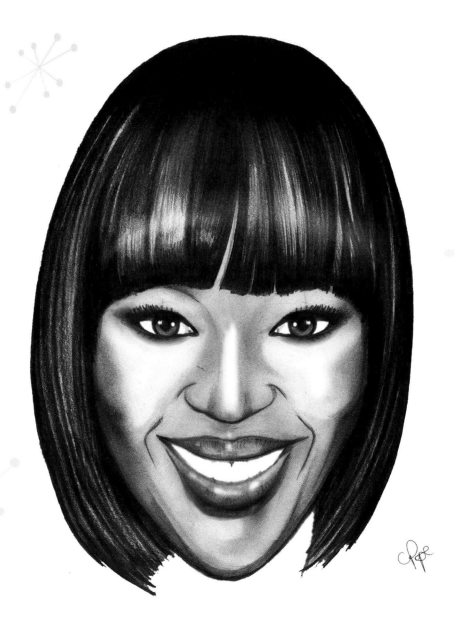

It is quite rare to have a symmetrical face. Combined with regular features, the effect is of someone usually regarded as very attractive. Individuals who make their living in front of a camera, such as supermodels and film stars, may fall into this category, but a large percentage of us do not. Fortunately for us caricaturists, most people have asymmetrical faces to some degree, giving them extra individuality and us more to work with.

To illustrate this further I have taken a photograph of a fairly average-looking man. If you look closely you will see that the eye on the left-hand side looks quite different from that on the right. The ears also do not match.

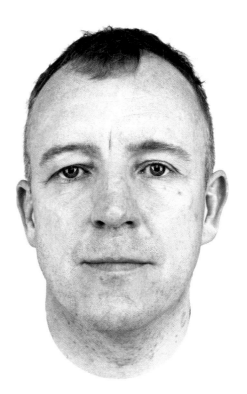

The two photographs below are mirror images of both the left- and right-hand side of his face, illustrating how he would look if he did have a symmetrical face. The images could be of two completely different people.

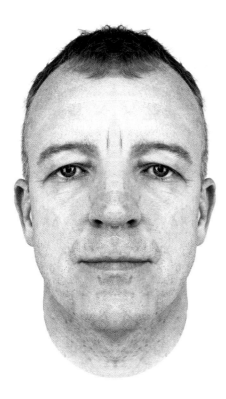

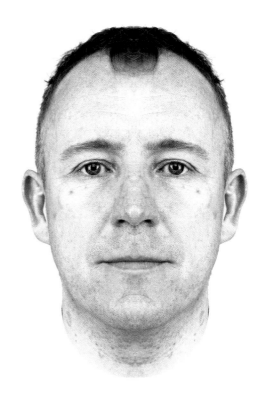

ILLINOIS PRAIRIE DISTRICT LIBRARY

# The Features in Detail

## EYES

Capturing a recognizable likeness of your subject's eyes plays a very important part in creating a good caricature. In this context, "eyes" also refers to the flesh and muscles that surround the eye itself together with the eyebrows and eyelashes.

We can learn a great deal about people by looking at their eyes. We can tell if one is happy, sad, excited, angry, surprised, frightened, and so on, and we can also get a rough idea how old they are.

Young children, for example, appear to have larger eyes than adults. This is not true, of course—it's just because their heads haven't finished growing, so their eyes take up a larger percentage of their face than an adult's do.

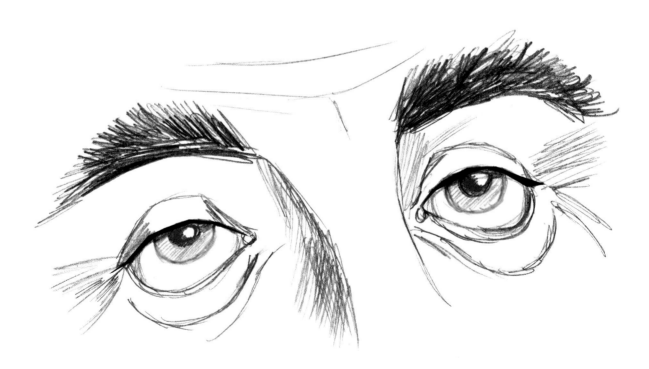

On an infant, the skin around the eyes is smooth, with few or no wrinkles. However, as we grow older, folds start to form in the skin all around the eyes. Laughter lines, crow's feet, bags—call them what you will, but everyone gets wrinkles eventually.

Also, the iris (the colored part of the eye around the pupil) starts to merge into the white of the eye as we grow older. It looks less sharp and clear than that of a younger person's iris, which has a definite contrast against the white of the eye.

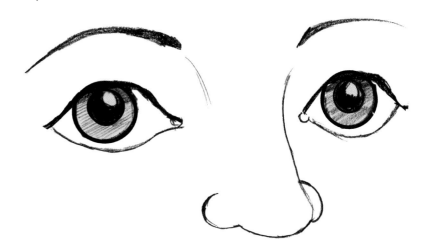

When drawing the eyes it's important to remember they are eyeballs, spherical in shape. Of course, a good percentage of the overall shape is hidden behind the lids and the flesh below the eye.

If you are drawing eyes looking up, down, or to the side, keep in mind that because they are spherical the iris and pupil will appear oval rather than circular.

When viewing the eye face on, the iris and pupil look circular.

The size of the pupils is affected by lighting conditions; in low light they increase in size and vice versa. The size is also affected by your subject's emotional state.

If your subject has light-colored eyes the pupils will stand out more in contrast to the iris.

In most people, the eyes are synchronized in movement and positioning. If you draw them out of synchronization it will give an odd appearance and not resemble your subject very well. If, on the other hand, they have one eye slightly higher than the other, exaggerate the amount.

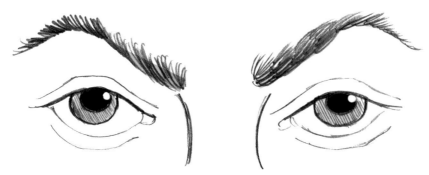

**Eyes in Synchronization**

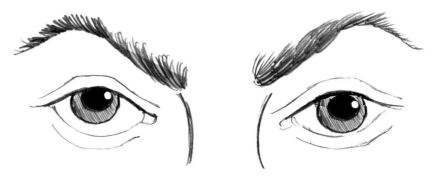

**Eyes Out of Synchronization**

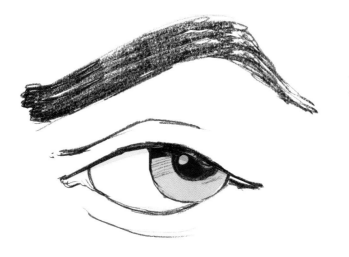

Men usually have thicker eyebrows than women and sparser eyelashes. Women often pluck their eyebrows and apply mascara to their lashes.

When drawing women's eyes, note if they are wearing makeup and how much, as this can affect their appearance considerably.

## EXPRESSIVE EYES

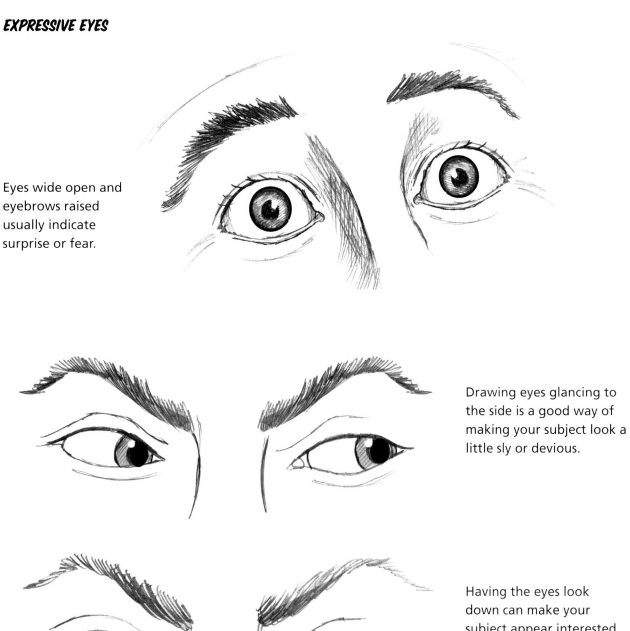

Eyes wide open and eyebrows raised usually indicate surprise or fear.

Drawing eyes glancing to the side is a good way of making your subject look a little sly or devious.

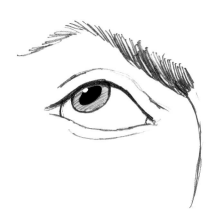

Having the eyes look down can make your subject appear interested in something.

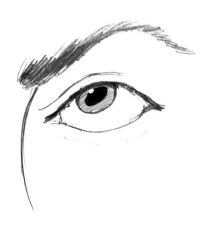

Eyes looking up express lack of interest or daydreaming.

## MOUTHS

Of all the facial features the mouth is the most flexible, taking on many different forms as people smile, laugh, purse their lips in disapproval, and so on. Its appearance in both size and shape can change significantly, so it can be quite complex to draw.

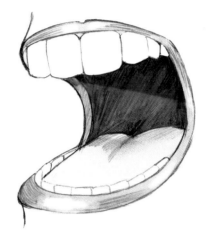

When someone is yawning or yelling the lips stretch and appear thinner as the mouth opens wide, exposing the teeth and the tongue. This is when the mouth looks at its largest.

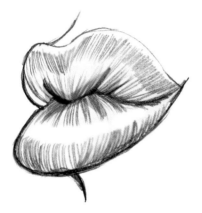

In contrast, this illustration shows the mouth puckered up for a kiss. The lips are drawn in tightly and appear fuller. In this form the mouth looks considerably smaller than in the illustration above. As the teeth and tongue are not on display it was less complex to draw.

The shape and fullness of the lips can vary a lot from one individual to another. Generally speaking the bottom lip is thicker than the top one and has a curved shape, while the top lip is usually flatter and bowed to a varying degree in the center.

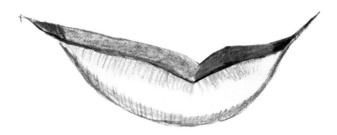

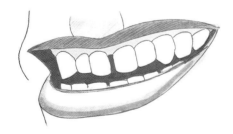

Sometimes teeth grow apart, leaving gaps between them. Anything that is unique is worth exaggerating.

**FULL LIPS ARE OFTEN SEEN AS BEING ATTRACTIVE, ESPECIALLY IN WOMEN, AND MANY CELEBRITIES HAVE PERFECTED A POUT THAT MAKES THE MOST OF THIS FEATURE.**

When people smile the amount of gum on display is also an individual characteristic worth noticing. Some have small teeth with a lot of gum showing, while others have big teeth with very little gum to be seen.

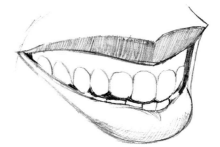

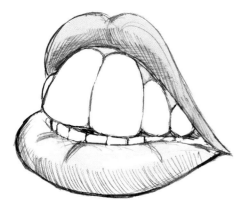

Here is an example of a set of teeth and lips caricatured to the extreme.

## LIPS

The lips can vary in size and shape from one person to another by a considerable amount. Women tend to have fuller lips than men, but this is not always so.

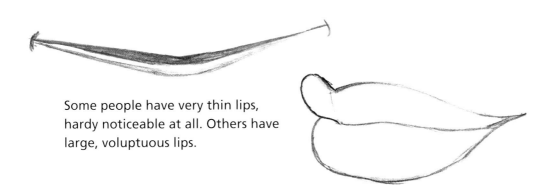

Some people have very thin lips, hardy noticeable at all. Others have large, voluptuous lips.

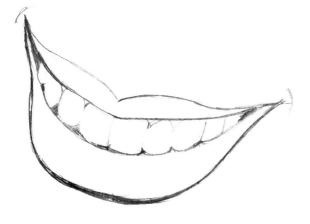

The bottom lip is generally thicker than the top lip and has a more curved appearance. The top lip has a more flat and chiseled look.

It's believed that the fuller women's lips are, the more attractive they are to men, so women tend to wear lipstick to enhance their shape.

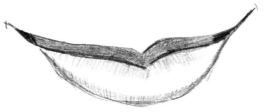

## NOSES

The nose is very often one of the most prominent features of the face and, dependent on its size and shape, could well be the main facial feature the caricaturist will choose to exaggerate.

There are certainly a vast selection of noses out there—hooked, upturned, bent, bulbous, snub, Roman, and so on. It's certainly worth paying a lot of attention to getting this part of the caricature right. Study the feature, find out what is unique about it, and then exaggerate it.

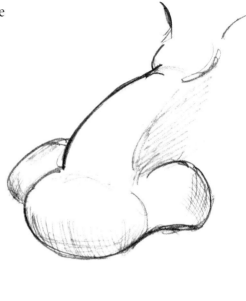

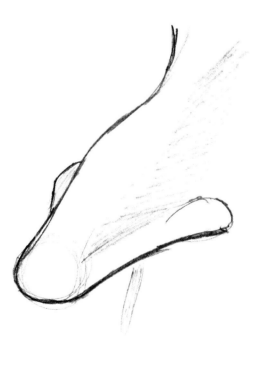

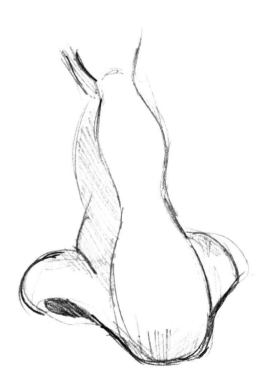

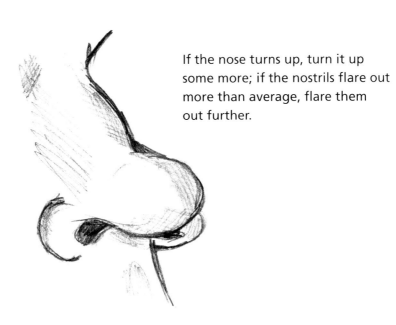

If the nose turns up, turn it up some more; if the nostrils flare out more than average, flare them out further.

Don't just exaggerate the size of the nose for the fun of it. Some caricaturists stretch the size of the nose of whomever they are drawing as a matter of course. If you do this, you run the risk of creating the reverse effect of what you are trying to achieve—a recognizable caricature of someone.

If the nose is average or small, leave it that way, and exaggerate some other features that warrant it. This way you will maintain a good likeness and create a great caricature.

THE LATE JOHN LENNON HAD AN INTERESTING NOSE. IT WAS NOT PARTICULARLY BIG, BUT IT WAS UNUSUAL, AND IT PROVED A LOT MORE DIFFICULT TO CARICATURE THAN I BELIEVED IT WOULD.

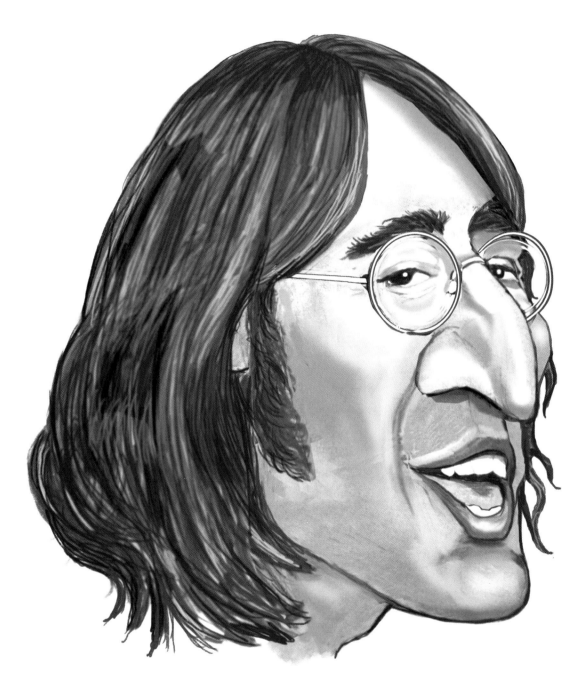

I noticed that most other caricaturists' attempts at Lennon were drawn full-face, and the nose certainly seemed a lot easier to capture from that angle. Taking the easy option is always tempting, but I wanted to draw my caricature of Lennon from a three-quarter angle and to make a feature of his nose. As you can see, it was not until I finished the caricature that I had to accept I got the nose wrong—it's too long and too hooked.

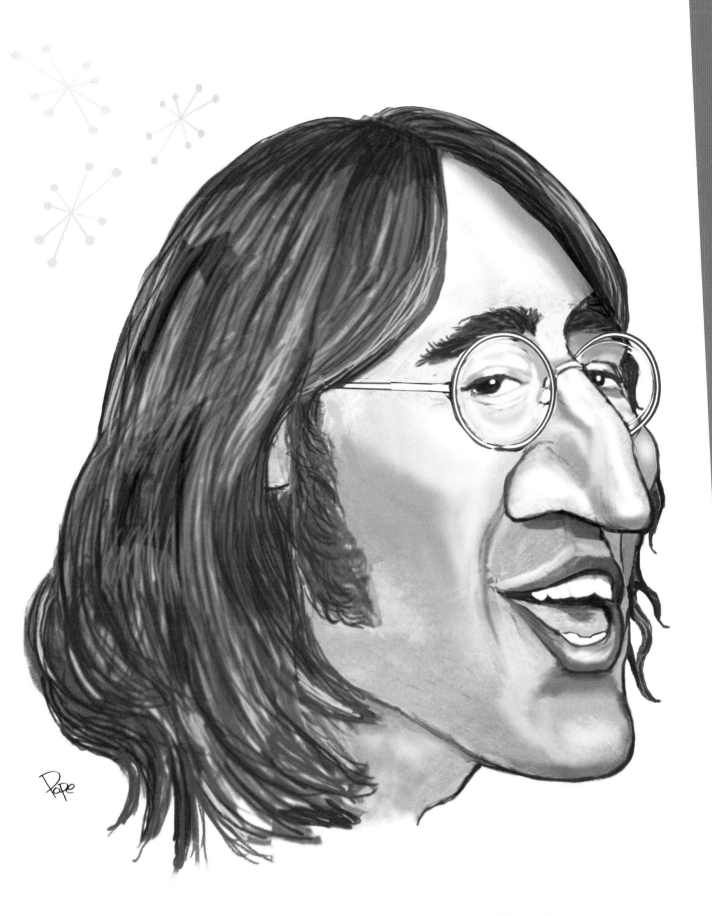

If you have been struggling to get a facial feature right, my tip is to give yourself a break. Upon your return, looking at your drawing with fresh eyes, you will often spot immediately what you could not previously see. Above is my final caricature of John Lennon—one that I am pretty satisfied with, particularly the nose!

## EARS

These flesh-covered cartilage appendages on either side of our head can vary quite considerably in size and shape. Take a look at the selection here.

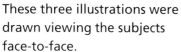
These three illustrations were drawn viewing the subjects face-to-face.

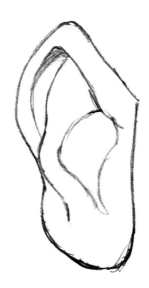

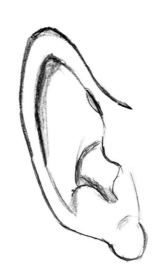

These ears were seen from a three-quarter angle.

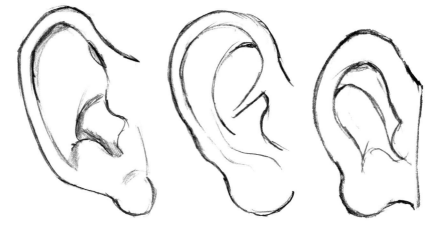

Only from a profile view can the whole shape of the ear be seen.

Depending on how large the ears are in comparison to the rest of the subject's features, they can sometimes be the main facial feature a caricaturist will focus on.

**38**

The two faces on this page are identical in layout and size apart from their ears. Each one has a different pair.

This one has short, stubby, sticking-out ears.

The ears on this illustration are long and lie almost flush to the side of the head, hardly protruding at all. Notice how the head on this illustration looks thinner than the other two. It's not—it just appears that way because of the ears.

This illustration has ears that protrude, and they are also quite long. Because of the overall percentage of area they cover, the head appears to be shorter and wider than those on the previous page. This illustrates how significant the ears are and why it's worth paying particular attention to their size, shape, and positioning relative to the rest of the facial features.

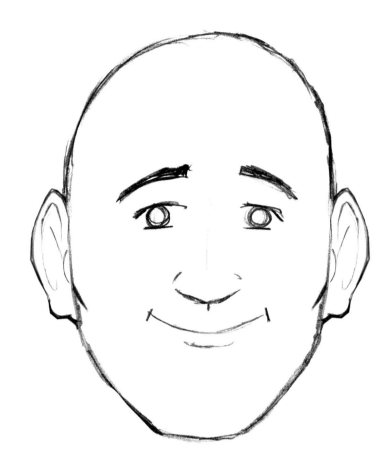

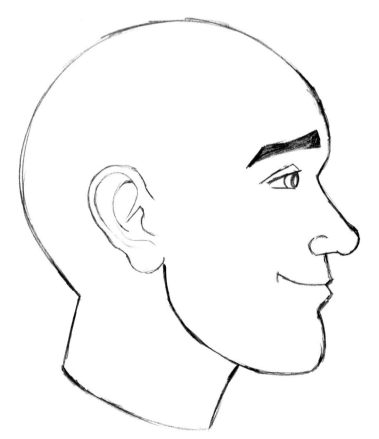

The three profile illustrations on these two pages are also identical, apart from the ears. However, as we are now viewing them in profile, we can see only one ear, and we can't see how far it protrudes from the head.

It's obvious that the ears here are all different in size, shape, and position. However, this doesn't drastically alter the overall appearance of our subjects as it does when viewing them face-to-face.

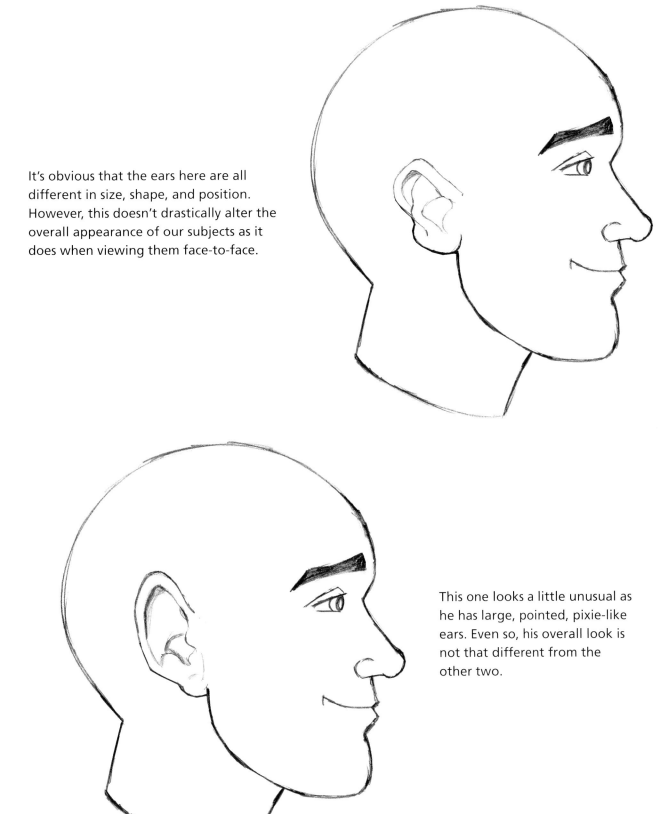

This one looks a little unusual as he has large, pointed, pixie-like ears. Even so, his overall look is not that different from the other two.

If your subject has large or unusual ears, choose either full-face or a three-quarter view to draw them from. This way you can take the opportunity to exaggerate their uniqueness.

## JAWLINES & CHINS

The basic appearance of the jaw is mainly determined by the shape and size of the jawbone. Just the shape of the jawbone alone can make a man appear more masculine or a woman more feminine. The two sketches below show the bottom half of the face from both sexes.

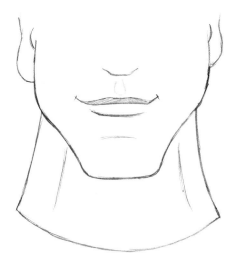

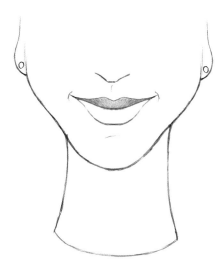

The man has a strong, powerful neck; a square chin; and a wide jawline.

The woman appears to have a longer neck than the man, but that's only because it's thinner and more elegant. The chin and jaw are more curved and pointed.

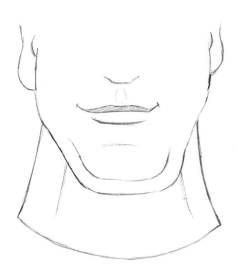

This sketch has drastically changed in appearance from the one above by virtue of our subject now sporting a double chin. Unfortunately, with age that extra layer of fat and skin tissue often appears.

When you are drawing a chin and neck in profile, note that the Adam's apple will be visible on a man's neck.

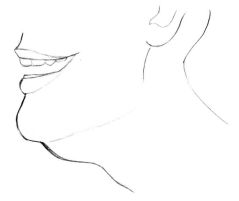

Here are the same jawlines as above, but with extra weight around the neck area.

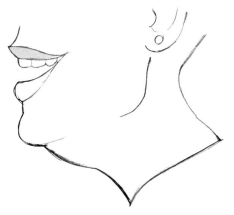

To the left, a rather large chin and angular jawline.

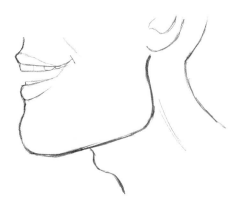

To the right, an average jawline with a small chin that slopes backwards.

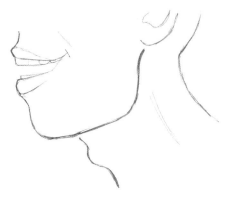

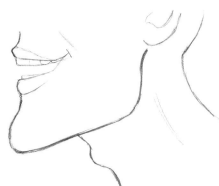

To the left, a long, pointed, protruding chin.

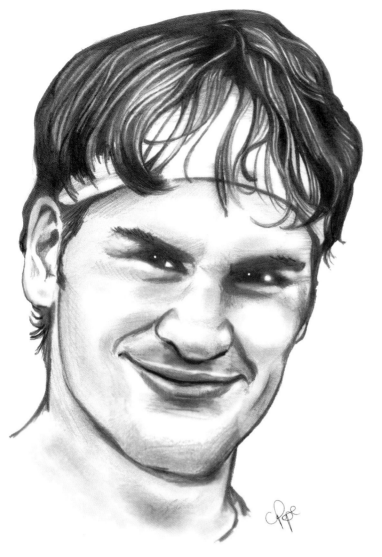

This is a portrait drawing of Roger Federer, probably the greatest tennis player of all time. It's a good likeness, but from this angle it's not apparent just how much Roger's chin protrudes. This is a good example of why it's essential to gather reference photos from all angles to identify the unique features of each subject you decide to caricature.

I drew this caricature pencil sketch from the same angle as the portrait above. As you can see, I have accentuated a number of Roger's features, but his chin has been my main focus.

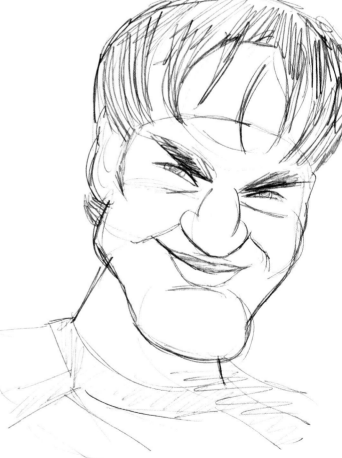

In the final image, you can sense the determination and shrewd judgement that make Federer such a formidable tennis champion.

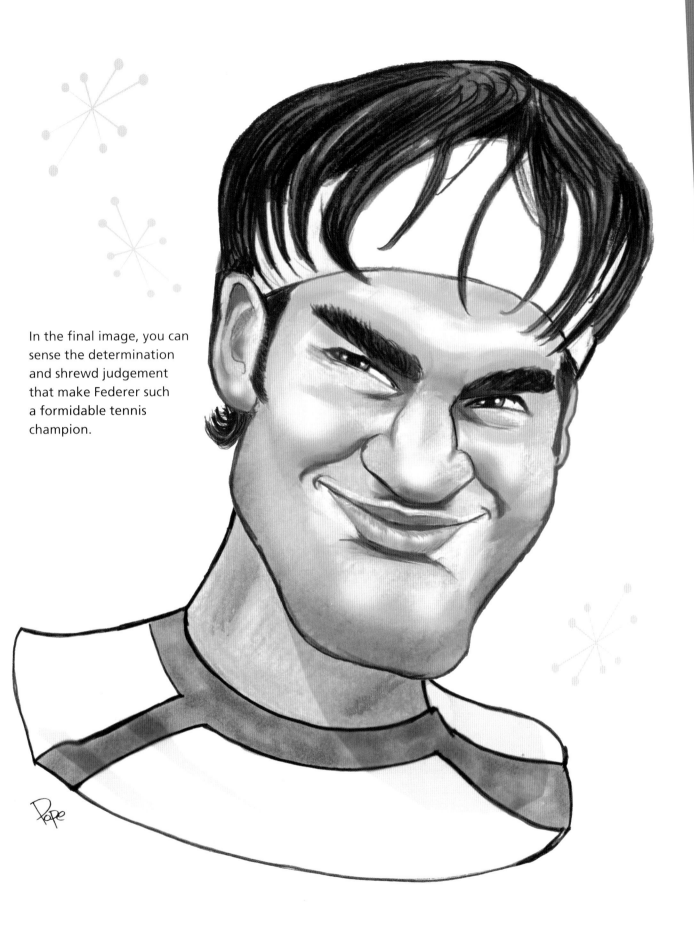

# Hairstyles

The hairstyle your subject chooses to wear can have a huge impact on their appearance and, right or wrong, the way they are perceived. Take a look at the characters below—they all have the same face but different hairstyles.

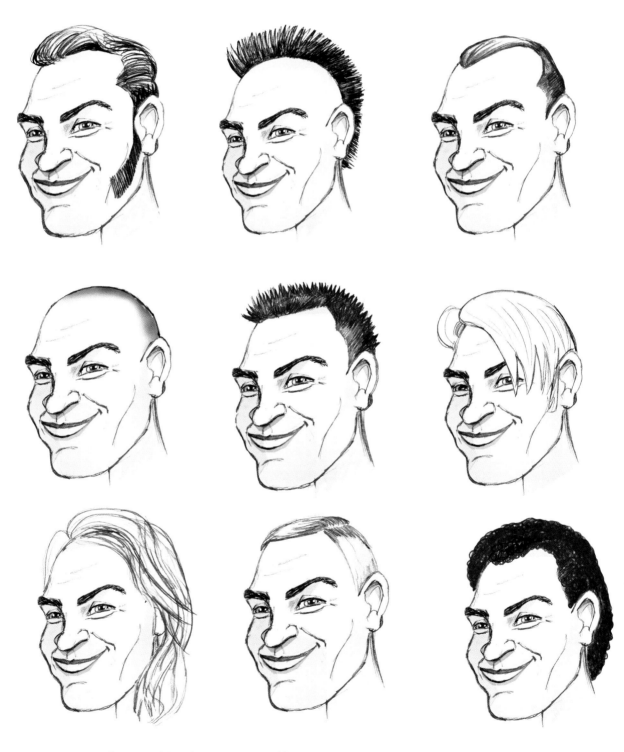

If your subject has an unusual hairstyle it is worth making a feature of it.
Identify what makes it unique and exaggerate it.

The three illustrations on the right are all of the same woman, drawn face-on. From this angle it is more apparent how much a change in hairstyle can influence the shape we see. On the far right are silhouettes of the same drawings. Looking at these purely as shapes, the difference between them becomes even more obvious.

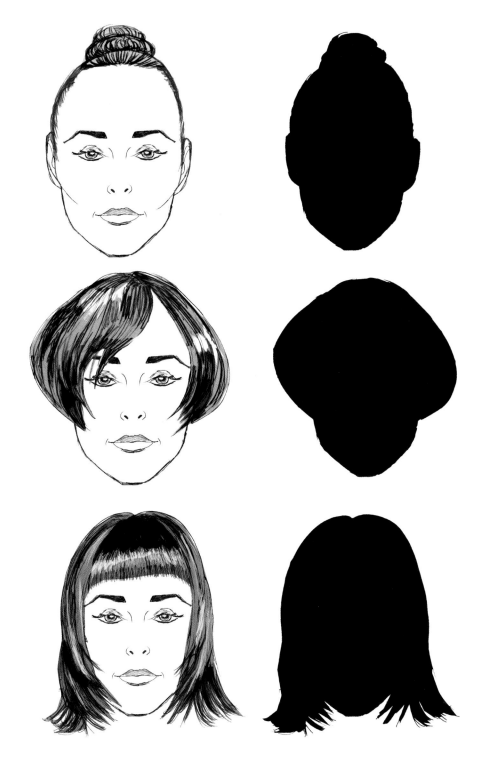

FILM STARS OFTEN CHANGE THEIR HAIRSTYLES OR WEAR WIGS TO SUIT A PARTICULAR ROLE. WHEN A POP STAR CHOOSES TO REINVENT THEIR IMAGE, A NEW HAIRSTYLE IS USUALLY FIRST ON THE LIST. FOR A TOPICAL CARICATURE MAKE SURE YOU'RE UP-TO-DATE WITH THEIR LATEST LOOK!

A beard and moustache can be such a defining feature of an individual's appearance that you might not even recognize him clean-shaven.

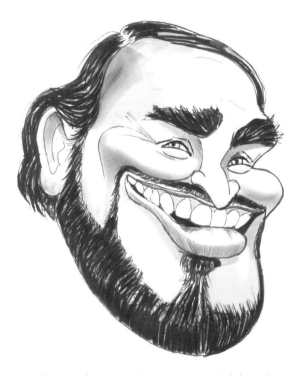 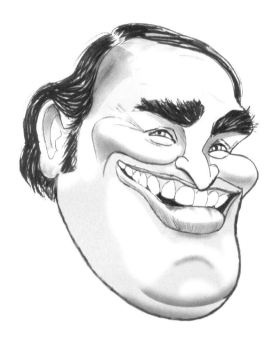

Opera singer Luciano Pavarotti (above) was immediately recognizable with his beard and mustache, but without them (above right) you would probably not recognize who the subject was. The same goes for the former U.S. president Abraham Lincoln (below). A beard with no mustache is quite an unusual look, which makes him easily distinguishable from other American political figures. Without the beard, his main identifying feature is lost.

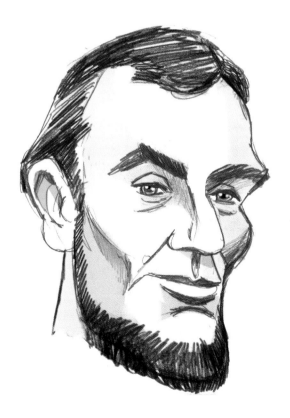 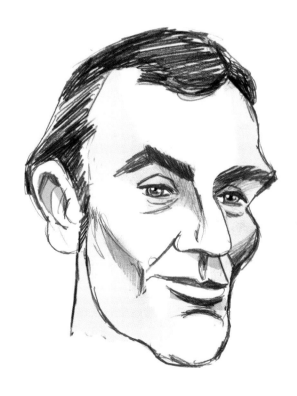

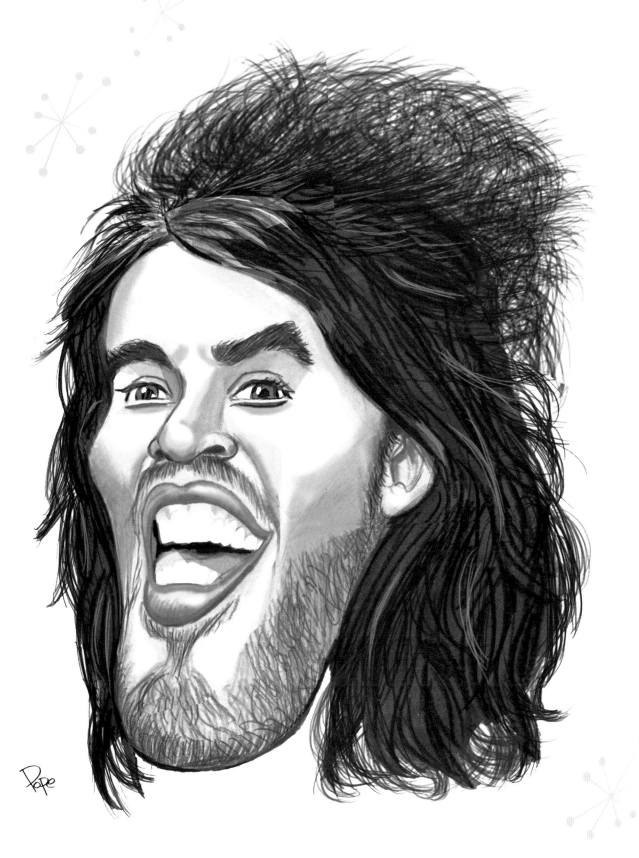

British comedian and actor Russell Brand was an ideal celebrity to caricature for this section. His wild, stylized hair, together with close-cropped beard and mustache, are all part of his extrovert image.

# Expressions

By looking at the expression on someone's face we can usually tell if they are happy, sad, excited, scared, aroused, and so on. As a caricaturist, your aim should be to identify the expression that is typical of your subject and then exaggerate it.

All the illustrations in this section are drawn without hair so that the focus is purely on the facial expressions.

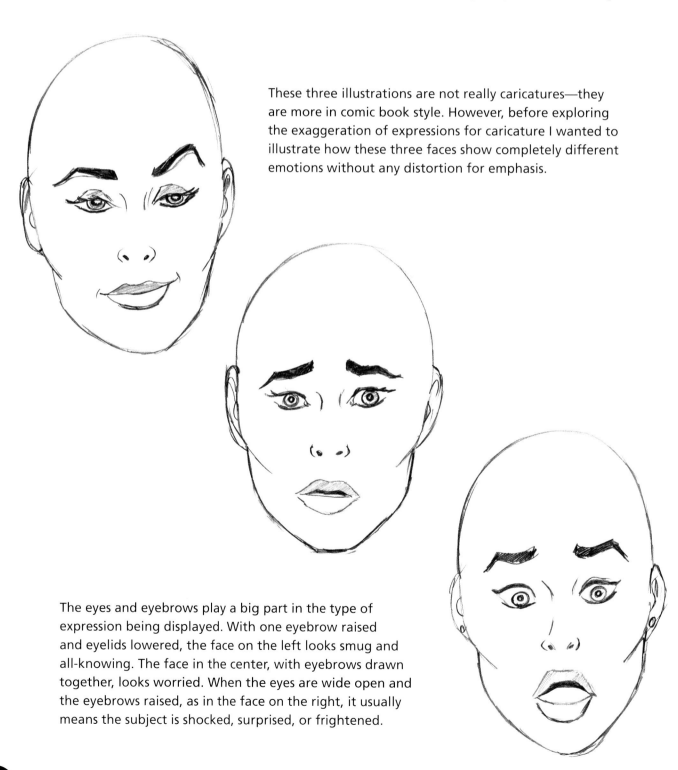

These three illustrations are not really caricatures—they are more in comic book style. However, before exploring the exaggeration of expressions for caricature I wanted to illustrate how these three faces show completely different emotions without any distortion for emphasis.

The eyes and eyebrows play a big part in the type of expression being displayed. With one eyebrow raised and eyelids lowered, the face on the left looks smug and all-knowing. The face in the center, with eyebrows drawn together, looks worried. When the eyes are wide open and the eyebrows raised, as in the face on the right, it usually means the subject is shocked, surprised, or frightened.

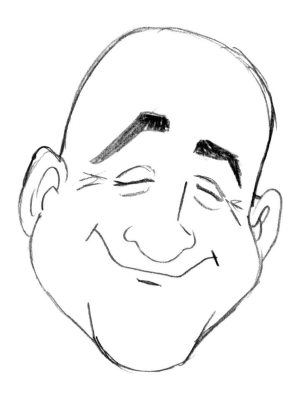

To illustrate the point about the eyes and eyebrows further, the three faces on this page are identical apart from their mouths.

In this illustration the subject has a big grin and is obviously finding something very amusing.

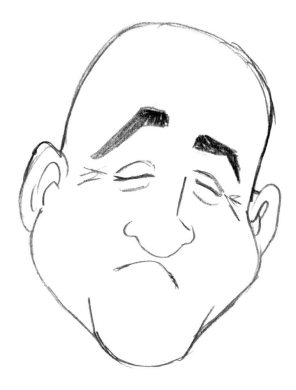

This subject has a down-turned mouth, which would usually indicate unhappiness. However, because of the way the eyes and eyebrows are positioned, the subject looks as if he could be trying not to laugh, or is just about to.

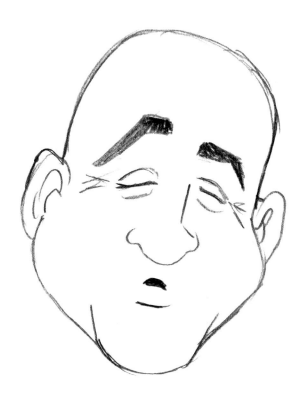

The mouth in this illustration usually signifies shock. However, again because of the position of the subject's eyes and eyebrows, he could be expressing joy, catching his breath in between laughter, or about to sneeze.

When I was a child I would doodle on my exercise books in class and as an adult, even before I became a professional artist, I would doodle while I was on the phone. Doodling—drawing freely with no definite purpose—is a great way of exploring expressions and movement. Just experiment—think happy, draw happy; think sad, draw sad—and you'll be surprised what you come up with. The faces and expressions illustrated on these two pages weren't supposed to resemble anyone in particular; they were drawn as doodles while I was thinking of various emotions.

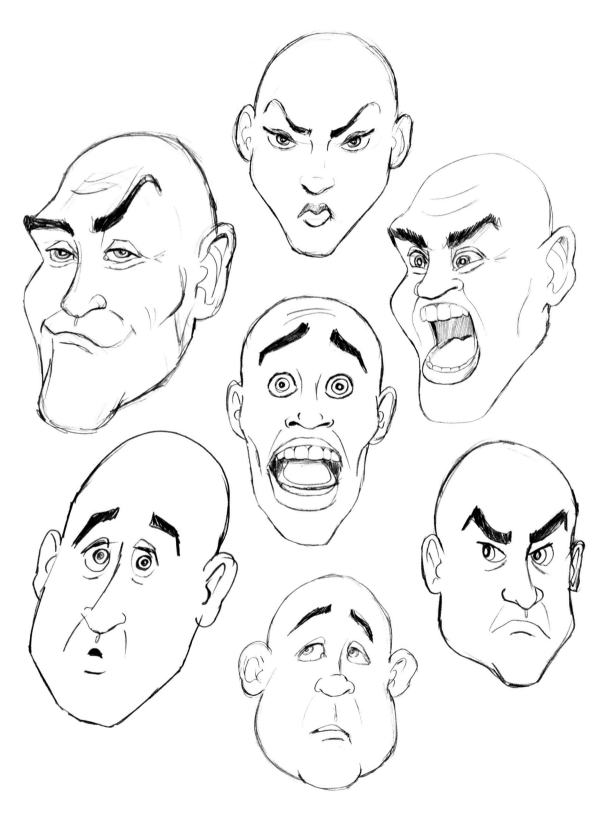

A good way to study expressions is to sit in front of a mirror and draw your own. Try to feel various emotions and make some quick sketches as you do so. Another thing you can do is take some digital photos of yourself or some other willing party pulling various expressions. You can then download them to a computer and save them on file for future reference.

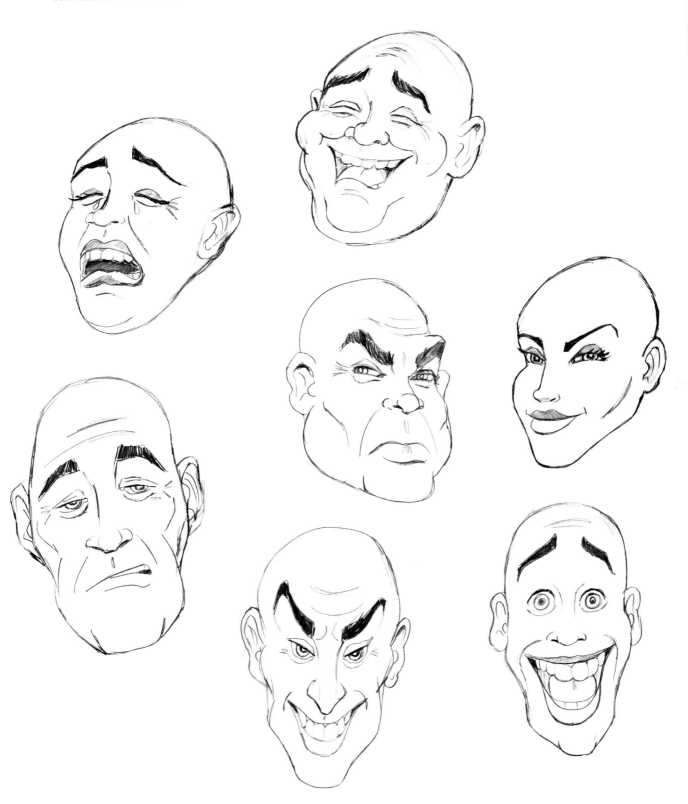

# CHOOSING THE RIGHT EXPRESSION

When it comes to capturing an accurate likeness of your subject, their expression is almost as important as their features. We all display a range of facial expressions, but there are some we use more than others and some that are unique to each individual. When I decided to caricature the movie star Will Smith, there was no shortage of reference photos available, but I couldn't find a single one that showed the expression I wanted to use.

Both eyebrows are raised but one is higher and more steeply angled than the other.

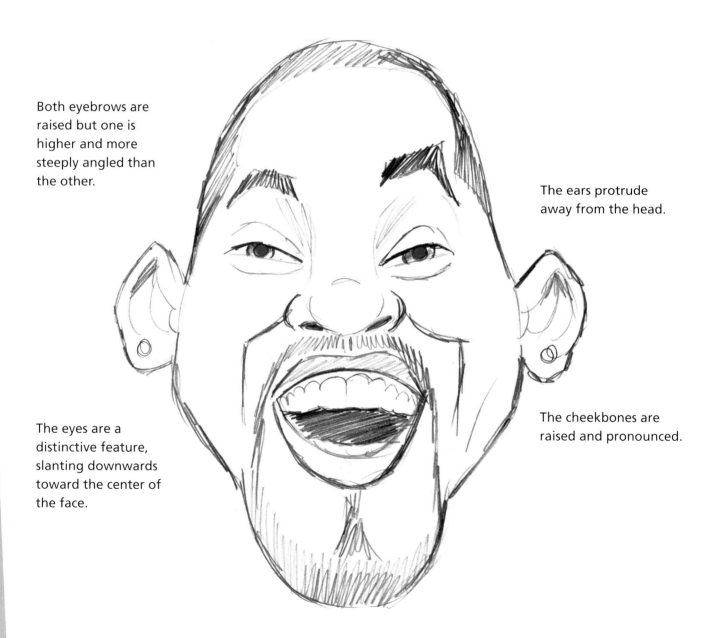

The ears protrude away from the head.

The cheekbones are raised and pronounced.

The eyes are a distinctive feature, slanting downwards toward the center of the face.

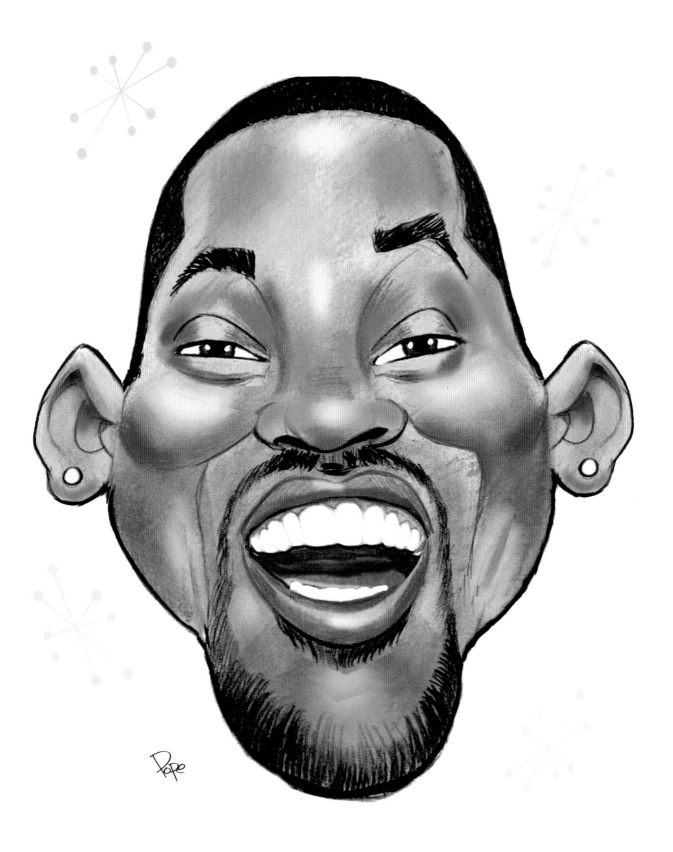

Will Smith has a very animated face, often displaying an abundance of energy and humor, and this is what I wanted to capture in my caricature. My reference for this came not only from an amalgamation of photos but also from my own memories of Will's numerous film and television appearances.

# Sourcing Reference Images

If you'd like to caricature a celebrity, it may be useful to spend some time sourcing photographs to use as reference. The best and usually most convenient way to find a good range of photos is to search the Internet.

If you don't have access to a computer you can always do things the old-fashioned way and take a trip to your local bookstore. There is now an abundance of gossip magazines consisting of little more than photos of celebrities as well as TV magazines and newspapers with plenty of pictures.

I usually collect as many photos of my subject as I can find, taken from every angle and displaying as many expressions as possible. Whatever angle you decide to draw your celebrity from, it's essential to build a mental three-dimensional image of what he or she looks like, as this will help enormously in capturing the essence of his or her character.

Once I have a reasonable selection of reference pictures to work from, I narrow them down to about five good ones. I usually choose one that has a good representation of the angle I wish to draw my caricature from and the others act as reference to help me create the ideal expression. You may sometimes be fortunate enough to find one photo that gives you everything you need, but generally this will not be the case.

# Caricaturing from Memory

It always pays to acquire good reference photos to work from, but it's not always feasible. If the individual you wish to caricature displays unique facial expressions, it may be possible to capture one of them from memory alone. To demonstrate my point I worked here from a photograph of the movie star Jack Nicholson, which didn't capture him with his most charismatic and characteristic look.

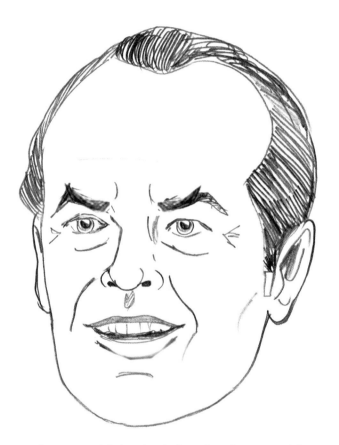 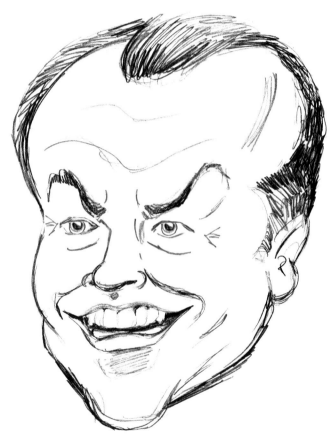

**Figure 1** This is a basic line drawing traced from the photograph—something I don't normally do, but it was useful for the purpose of this exercise. It doesn't look much like Jack at all, yet all the features are in the right proportion and in the right places. Needless to say, I didn't use this drawing as a guide to capturing Jack's character, only as a very rough guide for layout. Jack has such a strong screen presence that I found it quite easy to picture in my mind the facial expression I wanted to capture. The next three images illustrate the stages I went through in caricaturing the expression I wanted.

**Figure 2** Here Jack's eyebrows have been raised and increased in length slightly; they also curve inwards. The height of the hairline has been exaggerated to make the forehead larger by comparison with the rest of his face and I've given him less hair so that the hairline looks more defined. The mouth has changed to accord with how I remember Jack looked as the Joker in the 1989 film *Batman*. His nose isn't large compared to the rest of his features so I decided to reduce it further. Remember that exaggeration doesn't necessarily mean making something larger—it can equally apply to making it smaller.

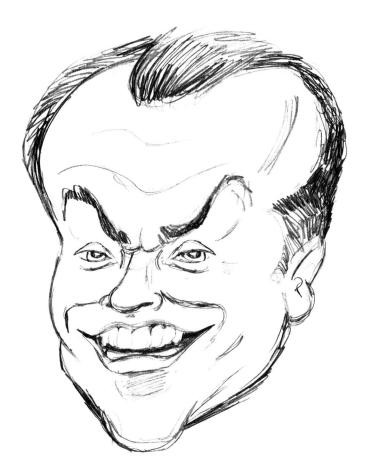

**Figure 3** Now I have made the mouth larger, forcing the cheekbones up higher. The nose has been reduced a little bit more and I have taken the eyebrows up even further. I have also increased the size of the forehead slightly. A small but very significant change has been made to the eyes; I've drawn the eyelids half-closed, covering part of the pupils and slanting downwards towards the center of the face. Jack's eyes don't always look like this, but it's fair to say it's a look that we identify him by.

**Figure 4** Comparing Fig. 1 with Fig. 3, I realized that by exaggerating the forehead and chin I had made the face look too thin, so I widened it. Unfortunately this meant that the nose was now a little on the small side so I made that larger and broader. Finally I added a little tone around the eyes, on the side of the face and under the nose and chin to make the caricature look more life-like and three-dimensional. Try this with one of your favorite movie stars; you may be pleasantly surprised at how much visual information you have stored away in your memory.

# Caricature Positions

## FACE-ON

Most caricaturists tend to draw their subjects either face-on or from a three-quarter view. While the latter has its advantages, the former is easier for a beginner as there are fewer angles and no perspective to worry about. If your subject's features look very asymmetrical or their ears stick out more than usual, drawing them face-on allows you to illustrate these characteristics to the full.

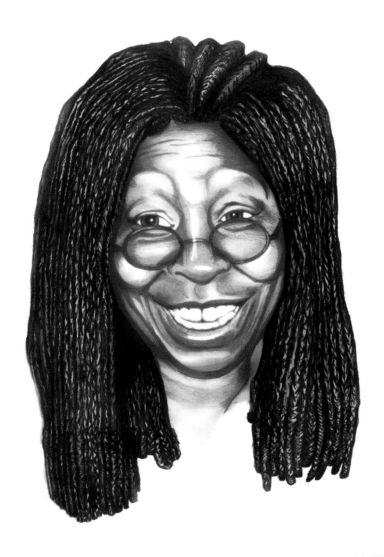

Whoopi Goldberg has a fairly symmetrical face and in this portrait her ears are covered by her hair. However, because she has such distinctive features she still makes a good subject to caricature face-on. As usual, I used a number of reference photos, including the one that acted as reference for this portrait. Looking at photos taken from various angles gave me a clearer idea of the position and angle of her teeth.

Whoopi has quite dramatic features, so it's fairly easy to see how they differ from the average. To help illustrate this further I have placed the portrait within the grid used on page 21, alongside our average head.

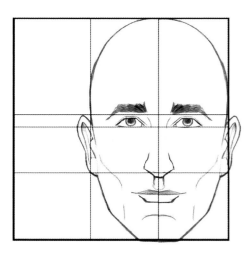

There isn't a huge difference in the alignment of the features, though the nose is quite a bit shorter and, considering the mouth is raised in a smile, there's a fairly large space between the base of the nose and the top of the mouth. What makes this face dramatically different is the size of the mouth, the width of the nose, the pronounced cheekbones, and the tapered jawline.

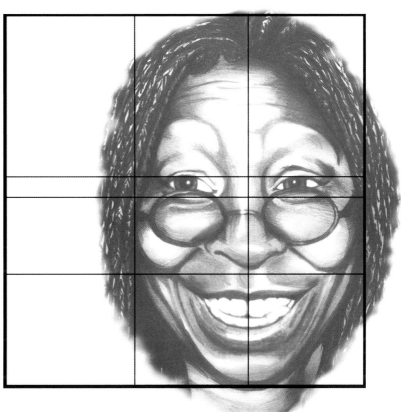

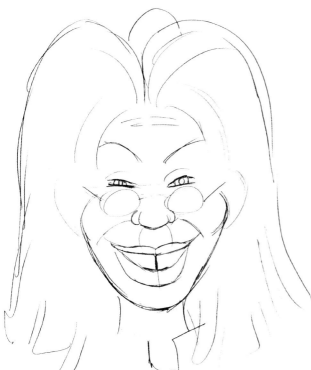

This was my first draft sketch. After consulting other reference photos I decided I wanted to make the hair more of a feature, rising to a greater height and looking less uniform than in the portrait opposite.

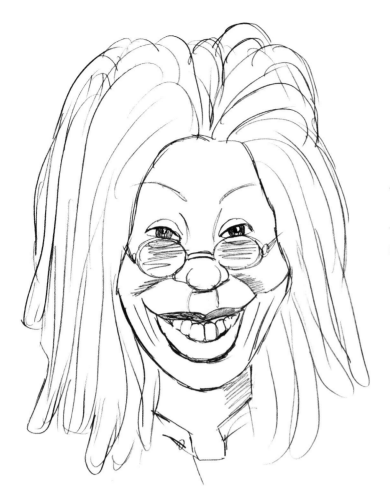

With more detail applied around the
mouth area and to the dreadlocks,
this caricature sketch started to show
some resemblance to my subject.

When tone is added to a sketch,
errors in the proportions are often
revealed. As soon as I blocked in the
hair I realized that the face needed
to be much wider.

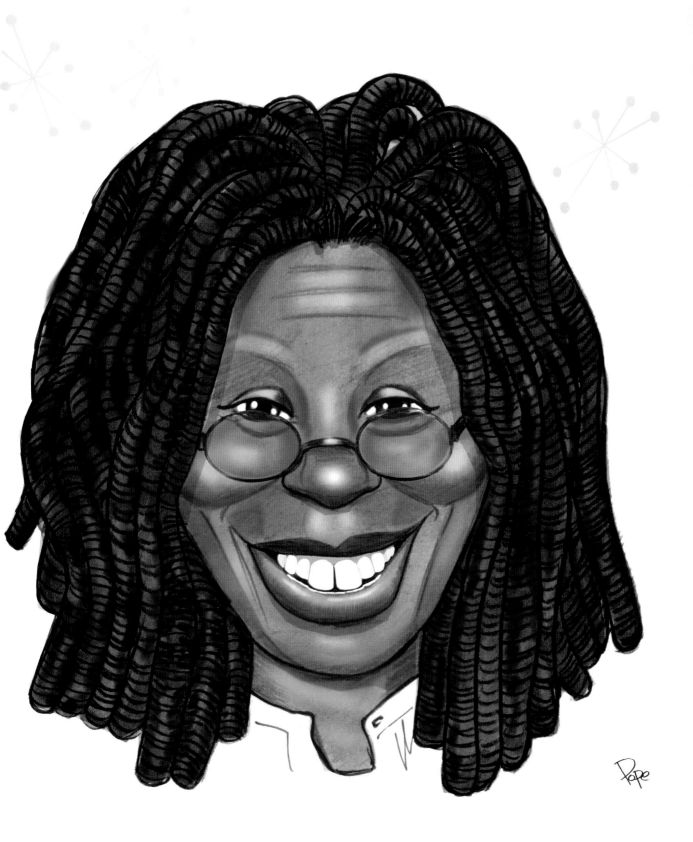

Here is the finished caricature, which I believe works well. The characteristic features that I chose to exaggerate are the large mouth, the gap between the front teeth, the large space between the top lip and base of the nose, the pronounced cheekbones, the almost non-existent eyebrows and, of course, the dreadlocks.

## PROFILE

If you try to look at yourself in profile using a mirror, you'll realize that it's nearly impossible. This explains why we're not very familiar with our own profile view—we only see it in photographs. However, we see the faces of celebrities so often we can recognize them just as well in profile as we can full-face. Caricaturing from the side view can be fun, especially if your subject has a large nose or an otherwise unusual profile.

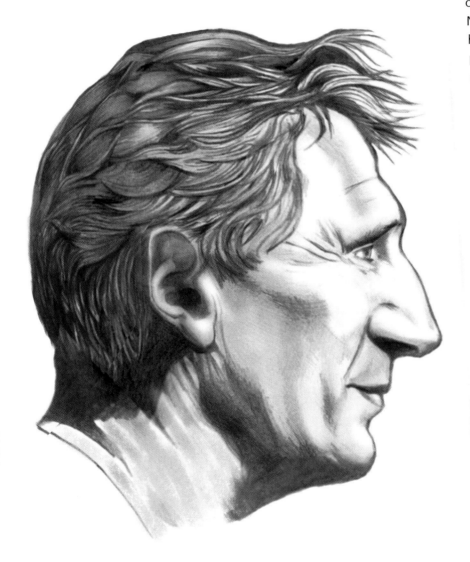

This is a pencil portrait of the film star Liam Neeson. As you can see, he has a very unusual profile, which makes him a perfect celebrity to caricature from a side-on view. I wanted to have my subject smiling in my caricature, so I needed more reference material for the mouth and cheekbones. As usual I turned to a range of reference photos, including the one used for this portrait.

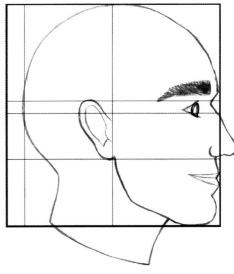

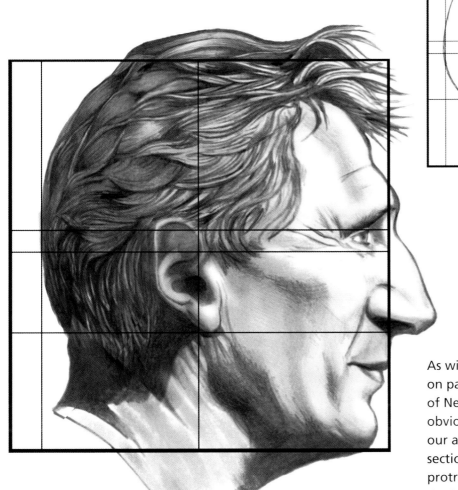

As with the face-on portrait of Whoopi on page 63, the unique characteristics of Neeson's face seen in profile are obvious. Comparing it in a grid with our average head, we can see that a section of the forehead juts forward, protruding outside the square, as does the bridge of the nose. The ear sits a fair bit higher than the guideline and the eye is very small. The chin is also quite small and sits back further inside the square than normal.

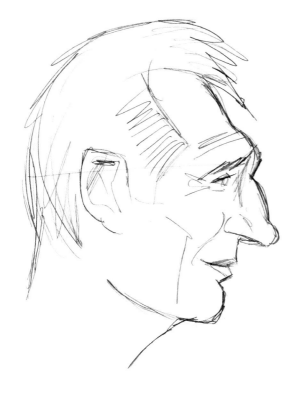

This was my first rough pencil draft. As you can see, I emphasized the information gained from the grid and a resemblance is forming.

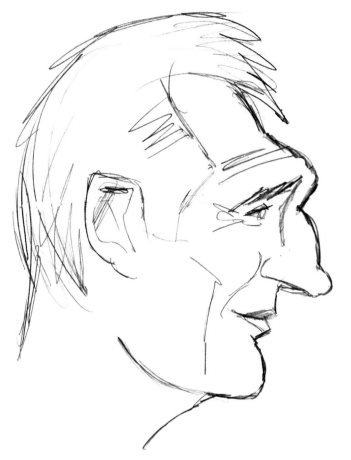

Using semi-transparent layout paper, I traced over my first sketch, making slight adjustments such as exaggerating the brow still further. Sometimes the adjustments you make in your early sketches are mistakes; in this case I made the jawline too strong.

My third attempt was a combination of both sketches with a few more adjustments on the way and some pencil shading. This time I made the jawline a little too small, but the sketch was good enough to use as the base for my final artwork.

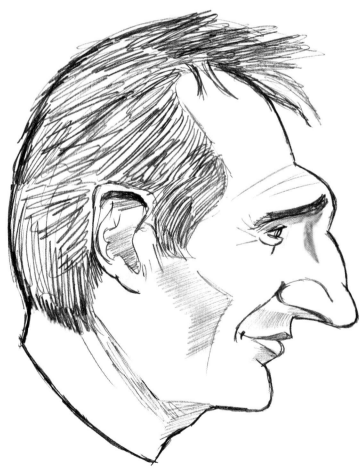

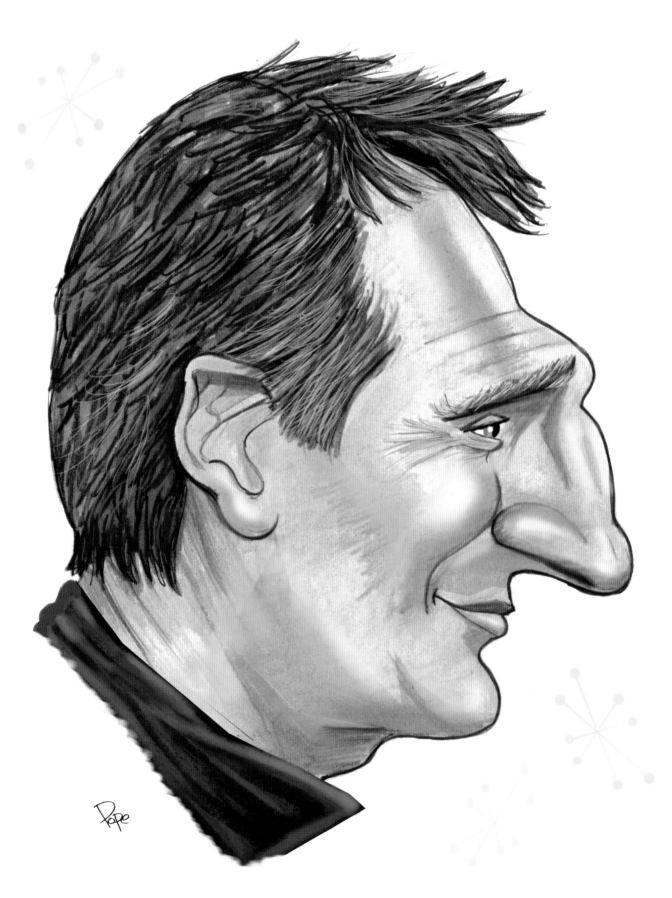

Here is my finished caricature of Liam Neeson. His protruding brow and unusually shaped nose were the key features that made him an excellent subject to caricature in profile. Other unique features include his inward-sloping chin, square-topped ears, and small eyes.

## THREE-QUARTER VIEW

The three-quarter view is probably the caricaturist's favorite angle to work from as it's possible to get a better all-around feel of the subject's features and how they relate to one another in size and layout.

The three-quarter view is an ideal angle from which to caricature someone. It pays to also view your subject from both the front and side before you start your three-quarter drawing, as you will gain different information from each angle.

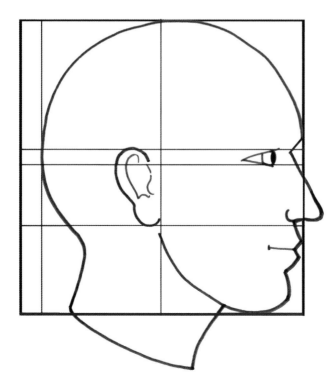

Take a look at this side view of the Face Base and compare it with our subject on the opposite page.

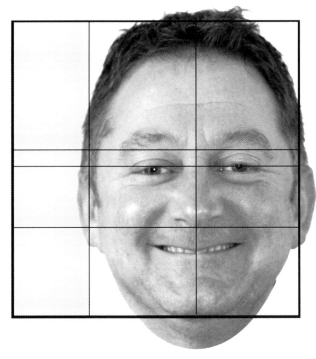
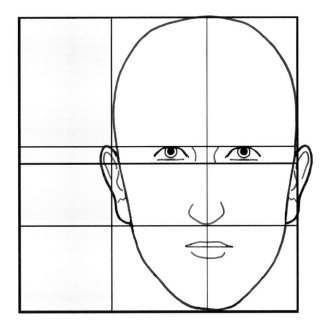

If we view our subject's face from the front and compare it with the Face Base, we can see his head is wider, taking up more of the square. The eyes are below the center line and one is slightly higher than the other. The smile is wide and the cheekbones are pronounced. We can tell the nose and chin are also pronounced, but from this angle we can't see by how much.

Viewing the subject from the side, we can see exactly how far the nose, chin, and forehead protrude.

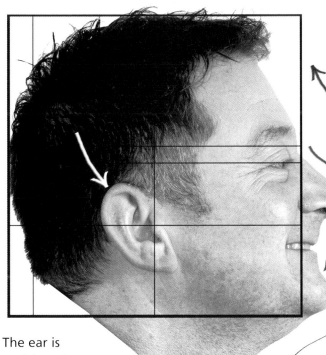

The forehead slopes away toward the back.

The nose protrudes far out of the square.

The mouth and chin are also positioned outside the square.

The chin juts almost as far outside the square as the nose.

The ear is positioned very low compared to the Face Base.

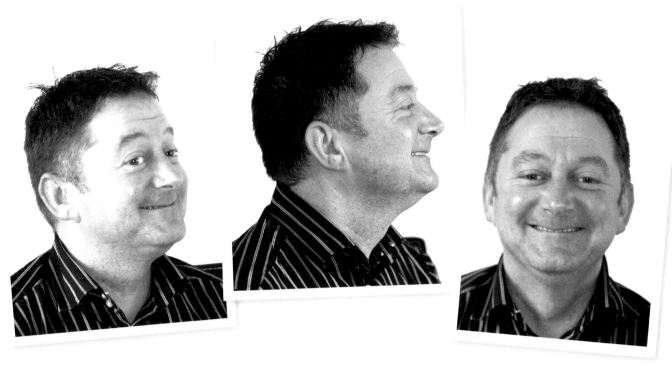

Now that we have gained information by studying the subject full face, in profile, and from a three-quarter view, let's have an attempt at drawing him.

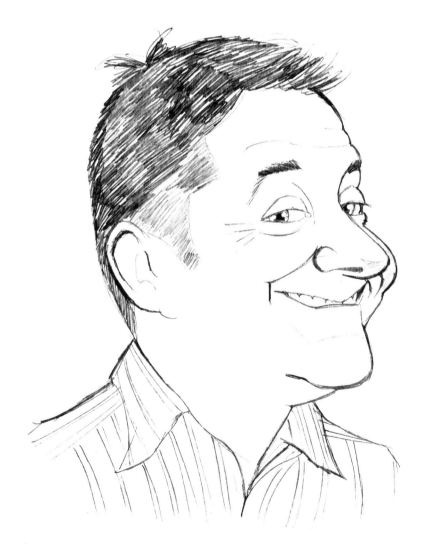

This was my first attempt. As you would expect, I exaggerated the nose and chin. I also emphasized the inward slope from the base of the nose to the top of the mouth and from the end of the chin to the bottom lip.

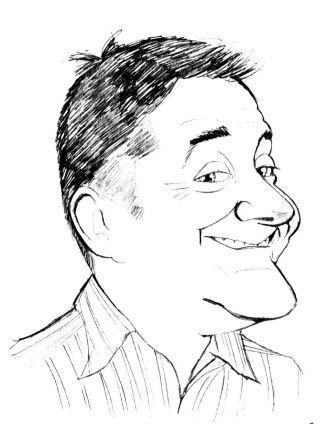

After drawing the first sketch I felt I had a resemblance, but it was obvious that the whole head needed to be wider. I also felt the chin and neck needed to drop down lower and jut out more.

After sloping the forehead back even further and increasing the width of the head a little more, I finished off by adding some tone. Note that even though the subject is smiling and showing his teeth, his lips meet in the middle. This for me was the most unique feature of the subject's face and well worth emphasizing.

# Caricature by Head Shape

Some caricaturists start by drawing the main facial features of their subject, adding the head shape afterwards. However, others prefer to sketch out a rough idea of the head first and put in the features afterwards. If you decide to take this approach, it's important to ascertain the shape of your subject's head at the outset.

Viewed face-on, the average human skull is fairly close to an oval shape. However, the shape of the head can alter quite dramatically from one person to another depending on how the muscle, fat, and skin tissue are distributed around the face.

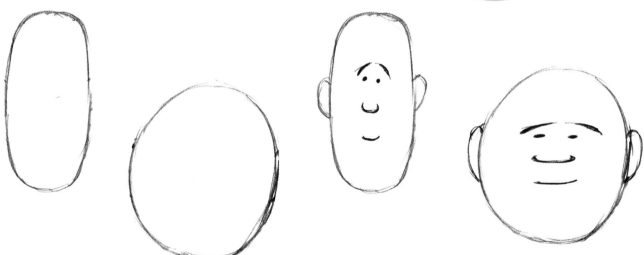

At first glance these odd shapes don't bear much resemblance to the human head, but as you can see, once a simple face and a pair of ears are added they take on a different form.

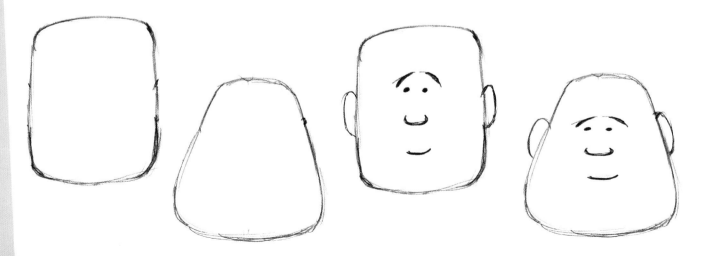

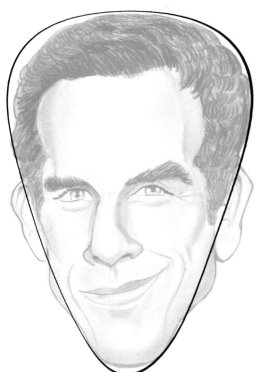

A line drawn around the basic shape of my caricature of Ben Stiller shows that his head is close to triangular.

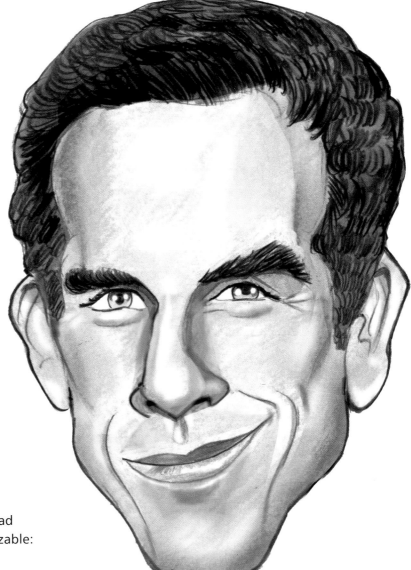

In the final caricature, you can see the unique characteristics that echo this head shape and that make the actor recognizable:

- His head is wider than average across the top, accentuated by his hairstyle.
- The bottom of his left eye is partly covered by flesh, caused by his distinctive smile.
- The bridge of his nose is wide and his ears protrude.
- His smile rises higher on the left than the right and his chin is narrow.

## CARICATURE BY HEAD SHAPE: STEP BY STEP

My caricature of Queen Elizabeth II has the opposite head shape to that of Ben Stiller—it's wider at the base than at the top. As it's drawn from a three-quarter angle, I had to establish this in my basic head shape.

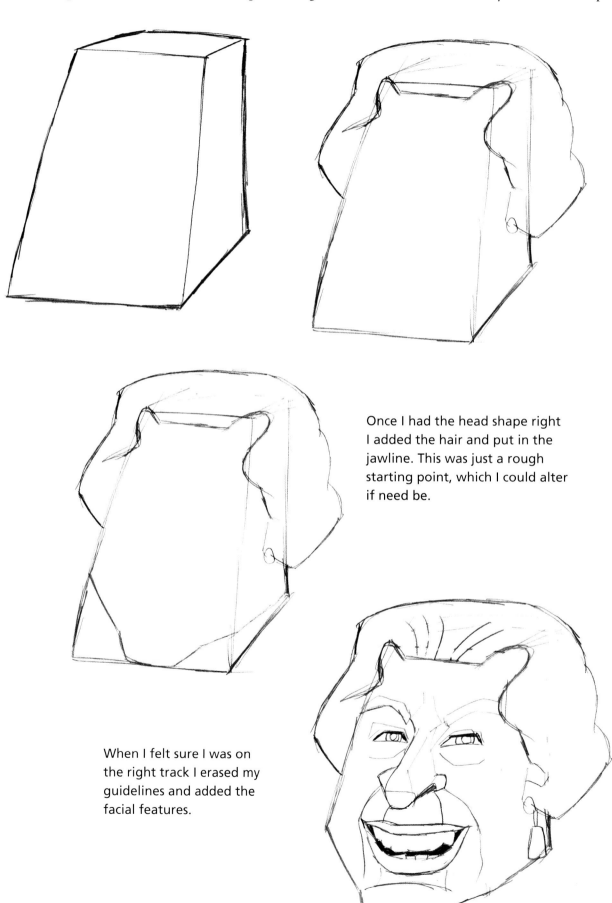

Once I had the head shape right I added the hair and put in the jawline. This was just a rough starting point, which I could alter if need be.

When I felt sure I was on the right track I erased my guidelines and added the facial features.

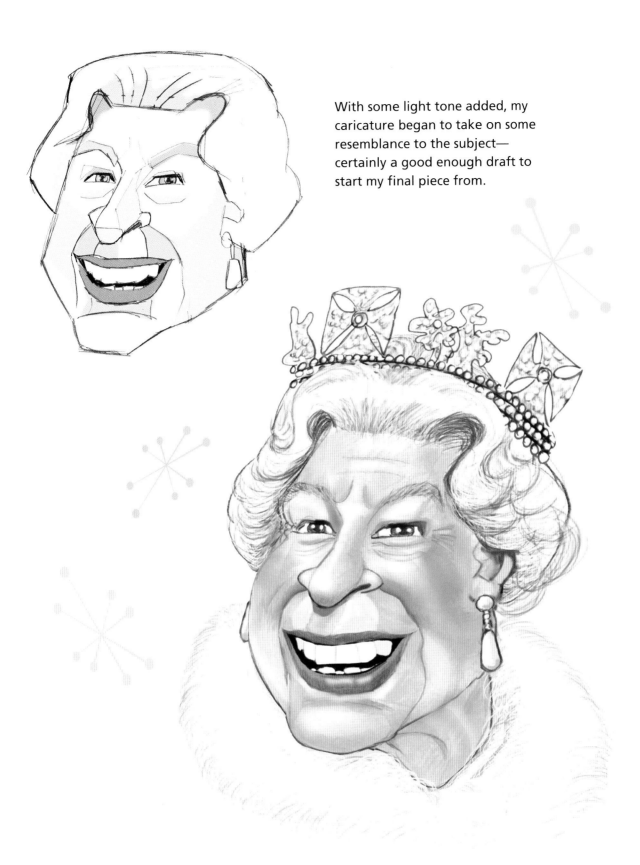

With some light tone added, my caricature began to take on some resemblance to the subject—certainly a good enough draft to start my final piece from.

The final caricature shows how I emphasized the unique features that make the subject immediately recognizable:

- Her face is broader towards the base.
- There is a larger-than-average space between her nose and top lip.
- The flesh above her top lip is full and pronounced.
- Her short chin juts forward.
- Her nostrils are flared.
- Her eyebrows are fairly thick.
- Her hairstyle is unusual.

# Body Proportions

Although caricaturists generally focus on their subjects' facial features, the heads we are drawing often need a body to accompany them—so it's important we have an understanding of the proportions of the human figure to enable us to draw them effectively. This subject is briefly covered here, but I strongly recommend you read a good book on human anatomy if you want to take this aspect of your drawing further.

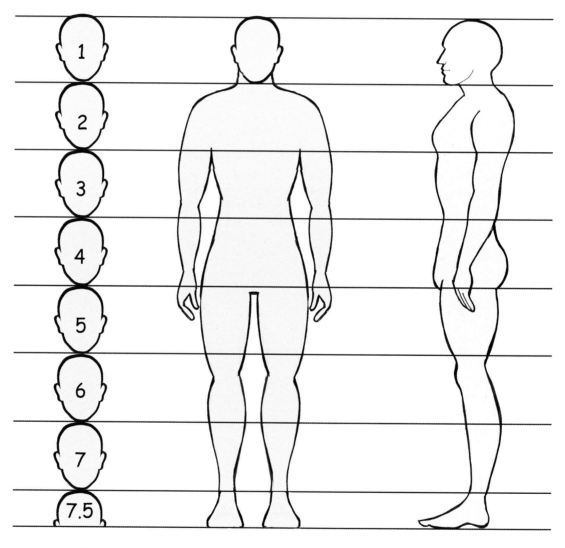

The above illustration is of the average adult male, shown both from the front and the side. As you can see, he stands approximately 7.5 heads high. It's important to remember that this is just a point of reference and proportions from one person to another may differ significantly.

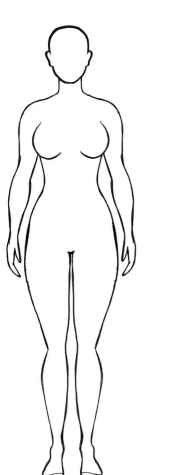

The average woman's body does not differ from that of a man in terms of head size in relation to overall height. However, on average a woman is generally shorter than a man, with proportionally narrower shoulders and broader hips.

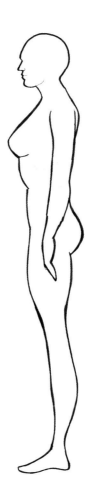
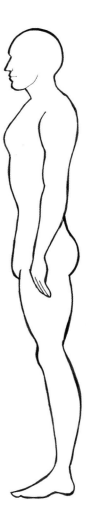

Viewed from the side, a woman's breasts and more pronounced buttocks account for the main visual difference between the sexes. The male form, whether viewed from the side or the front, is less curvaceous than that of the female.

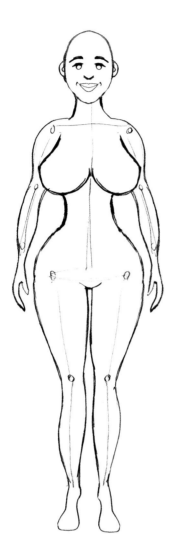

Caricaturing the body is no different from caricaturing the face in terms of the approach you need to take; as before, establish what is unique about your subject, and then exaggerate those elements. The illustration to the left is a caricature of the female form seen from the front. The body characteristics that define the figure as female have been exaggerated to excess, giving her disproportionately large hips and breasts.

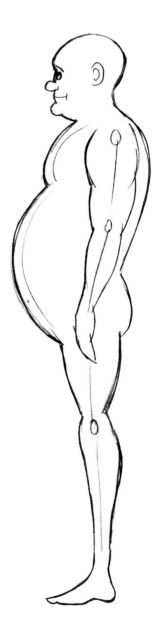

This illustration is a caricature of a middle-aged male viewed from the side. Unlike women, men tend to put on most of their weight around the waist rather than the hips. Through lack of exercise, their legs tend to become skinny and their buttocks shrink. As with the illustration above, I have exaggerated the elements that define the gender of the figure. However, if your male subject were skinny or a female had small breasts you would find another part of their anatomy that was worthy of exaggeration.

The caricature sketch to the right has all the elements of the typical tough guy, with a narrow waist and huge shoulders, biceps, and pectorals. The neck is so thick it's the same width as the waist.

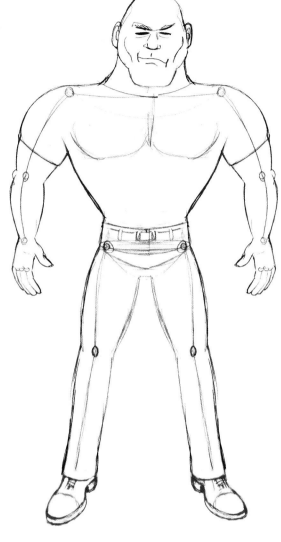

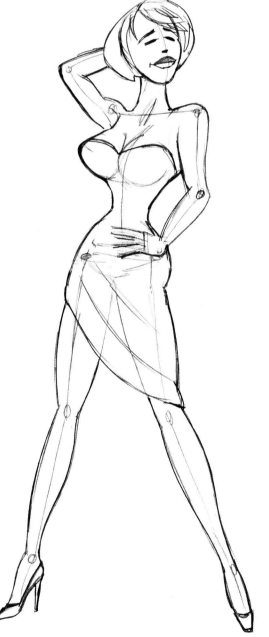

This illustration displays all the body proportions of a glamour model, exaggerated to the extreme—large, uplifted breasts, long slim legs, a slender neck, and a tiny waist.

# Posture

By reading a person's body language we can gain an idea of his or her emotional state. To do that we need to look for three things: facial expression, gestures, and posture. As with expressions, some people give away more information than others from their posture. However, in the same way that the face layout doesn't necessarily reflect how someone is feeling, the posture can be just the way they are made. For example, if someone has a downward-tilted head and slumped shoulders, we may well think that person is depressed, when the truth is that it's just a natural posture.

Whatever the reason for their posture, if it's unusual, the same rule applies when you are caricaturing: identify what it is; then exaggerate it.

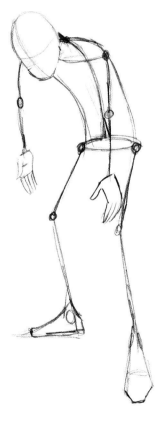

This subject is not looking altogether happy. His head is angled downwards, looking toward the ground, and his shoulders are slumped. His arms are hanging lifelessly by his sides and his legs are bent at the knee.

In this illustration I have emphasized our subject's posture slightly by slumping his shoulders more, bending his legs further, and curving his spine to create more of a stoop. Overall, his posture looks even more negative than the original.

Here, I have exaggerated our subject's posture to the extreme. His back and knees are bent further, creating even more of a stooped posture. He now looks as if he has the whole world on his shoulders.

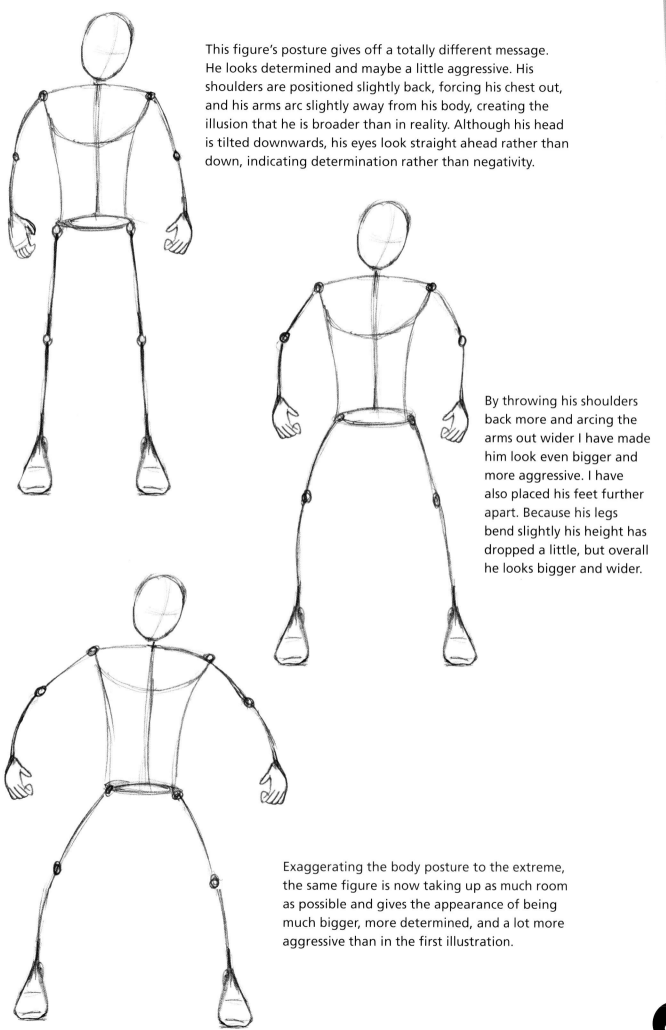

This figure's posture gives off a totally different message. He looks determined and maybe a little aggressive. His shoulders are positioned slightly back, forcing his chest out, and his arms arc slightly away from his body, creating the illusion that he is broader than in reality. Although his head is tilted downwards, his eyes look straight ahead rather than down, indicating determination rather than negativity.

By throwing his shoulders back more and arcing the arms out wider I have made him look even bigger and more aggressive. I have also placed his feet further apart. Because his legs bend slightly his height has dropped a little, but overall he looks bigger and wider.

Exaggerating the body posture to the extreme, the same figure is now taking up as much room as possible and gives the appearance of being much bigger, more determined, and a lot more aggressive than in the first illustration.

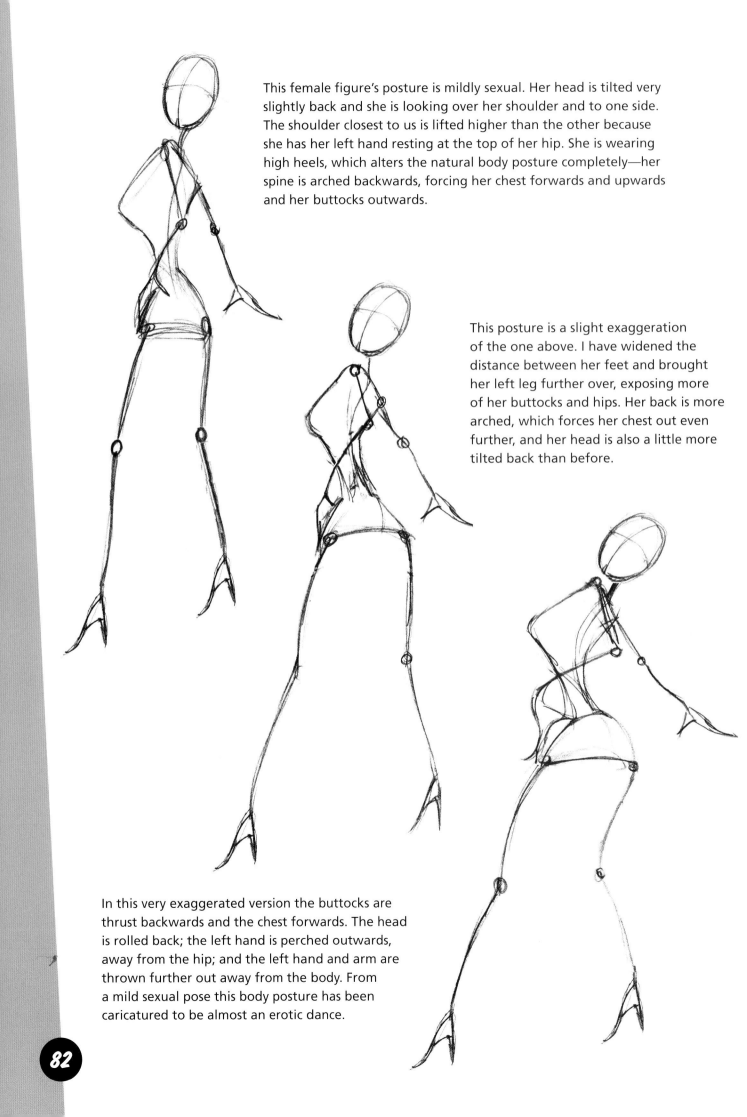

This female figure's posture is mildly sexual. Her head is tilted very slightly back and she is looking over her shoulder and to one side. The shoulder closest to us is lifted higher than the other because she has her left hand resting at the top of her hip. She is wearing high heels, which alters the natural body posture completely—her spine is arched backwards, forcing her chest forwards and upwards and her buttocks outwards.

This posture is a slight exaggeration of the one above. I have widened the distance between her feet and brought her left leg further over, exposing more of her buttocks and hips. Her back is more arched, which forces her chest out even further, and her head is also a little more tilted back than before.

In this very exaggerated version the buttocks are thrust backwards and the chest forwards. The head is rolled back; the left hand is perched outwards, away from the hip; and the left hand and arm are thrown further out away from the body. From a mild sexual pose this body posture has been caricatured to be almost an erotic dance.

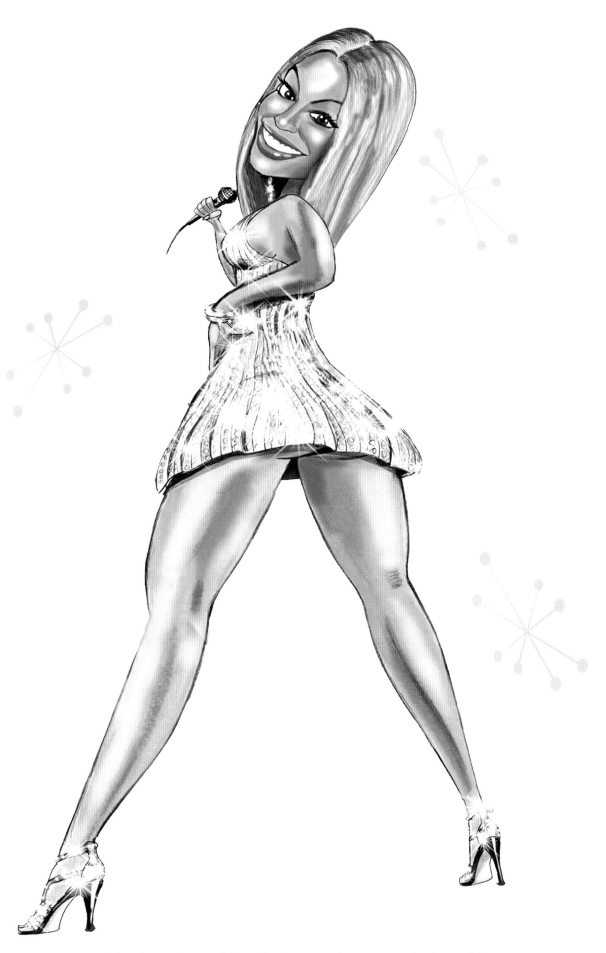

The singer Beyoncé Knowles has very long, attractive legs with wide, curvaceous hips. In this caricature I have not concentrated on her facial features, but on her female form and provocative body posture.

# Gestures

Gestures, like body posture, can help us to identify how someone is feeling. The difference is that people are usually aware they are making them—they are a deliberate means of communication, most often through the use of the hands. Gestures are very visual and when employed correctly can be a powerful means of bringing your caricatures to life. They can also help to make them more humorous.

The illustrations on the next few pages are simple sketches that lack faces to illustrate how effective gestures can be using just a few lines.

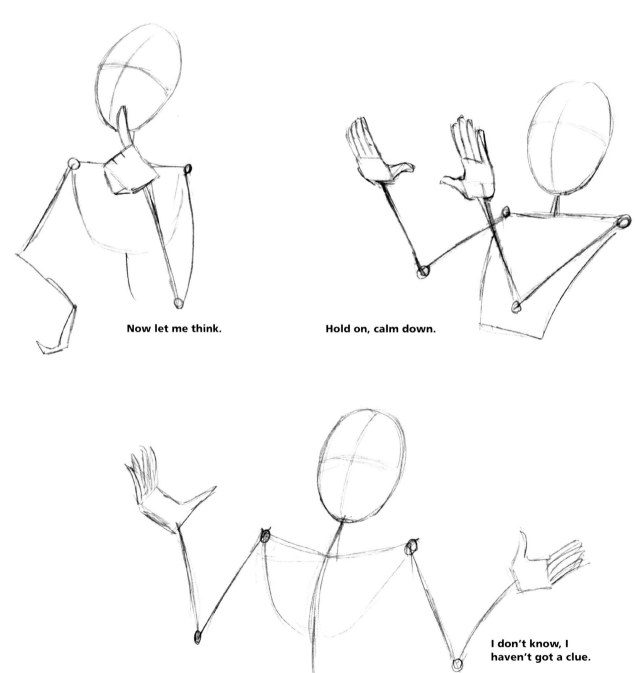

**Now let me think.**

**Hold on, calm down.**

**I don't know, I haven't got a clue.**

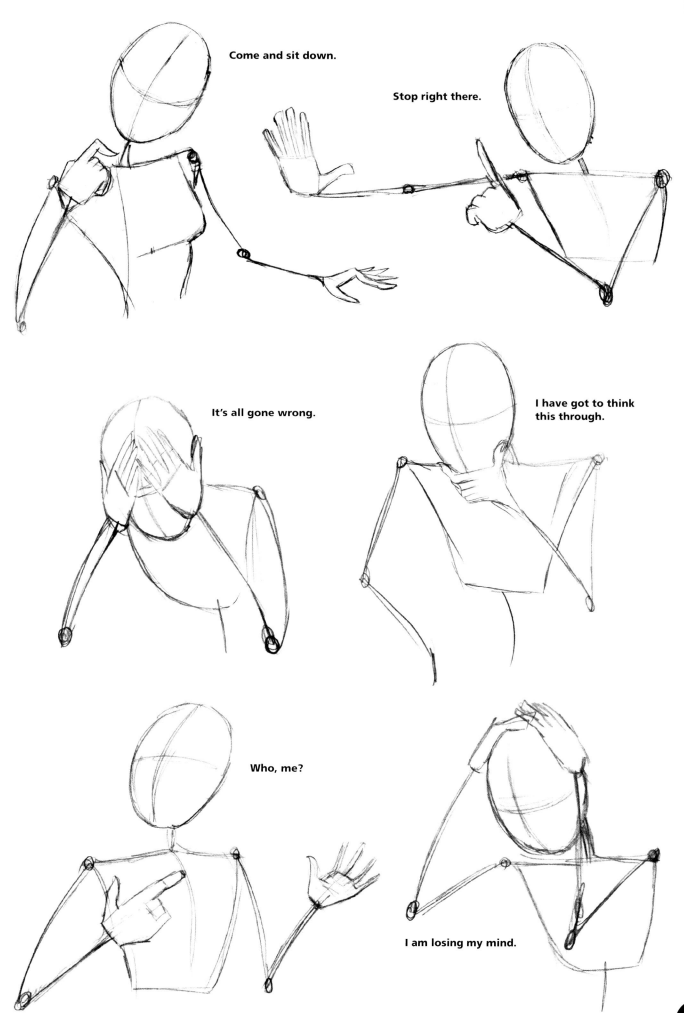

Come and sit down.

Stop right there.

It's all gone wrong.

I have got to think this through.

Who, me?

I am losing my mind.

85

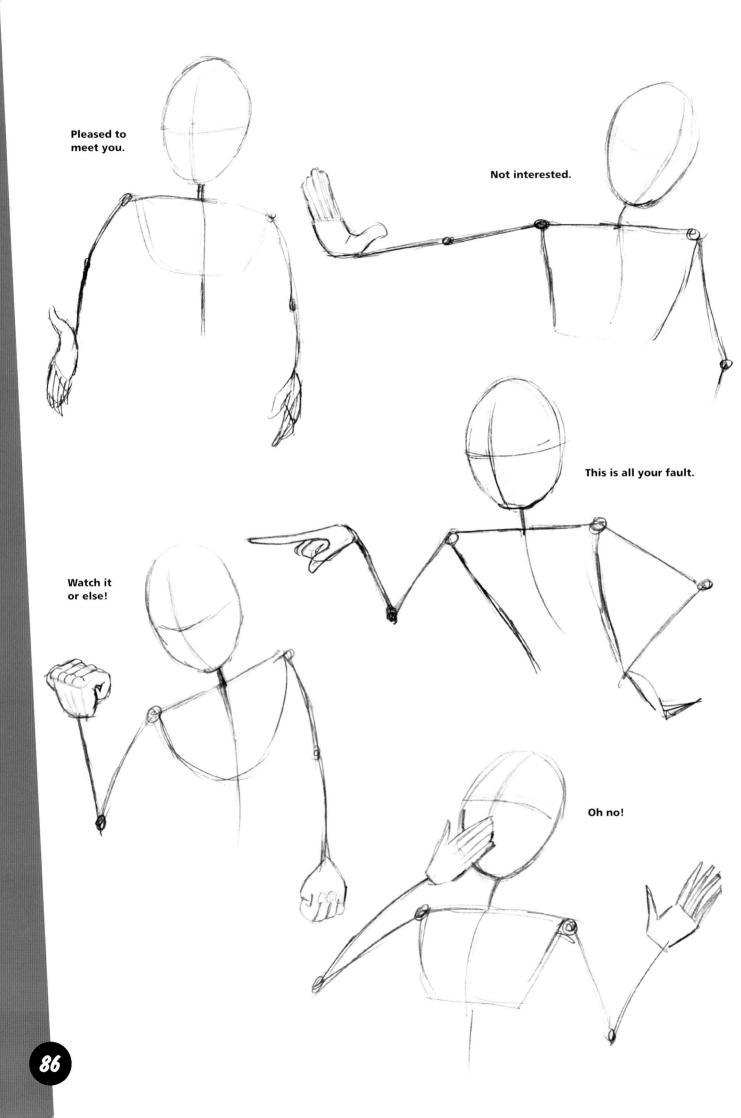

Pleased to meet you.

Not interested.

This is all your fault.

Watch it or else!

Oh no!

86

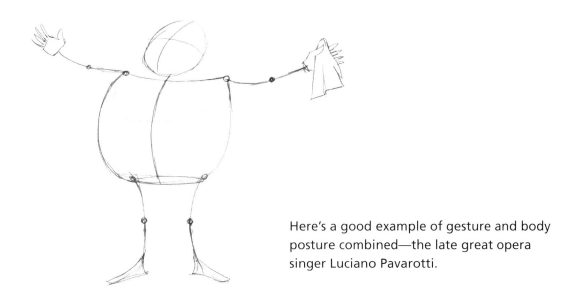

Here's a good example of gesture and body posture combined—the late great opera singer Luciano Pavarotti.

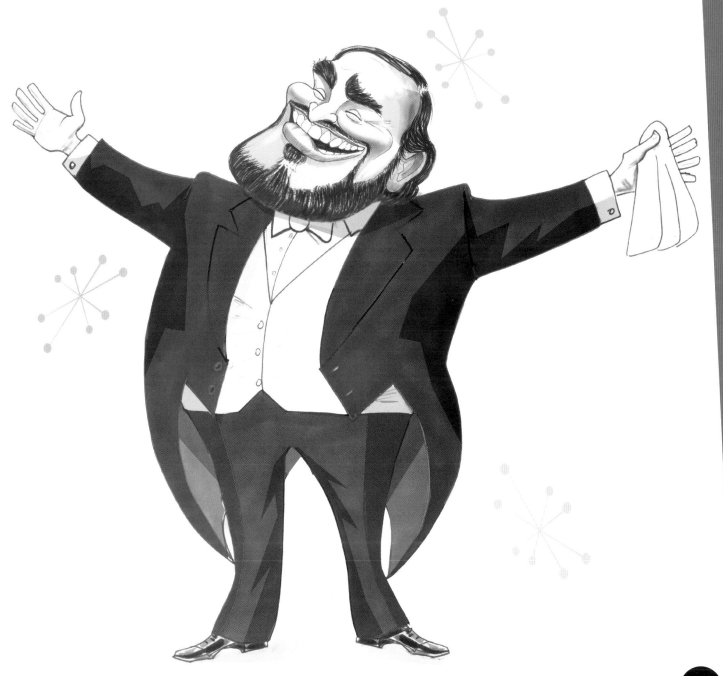

# Props & Clothing

When props and clothing are used effectively, they alone can make a very average caricature recognizable. However, don't fall into the trap of illustrating props and clothing as a substitute for working on your caricaturing skills—use them to enhance an already successful caricature with humor and realism.

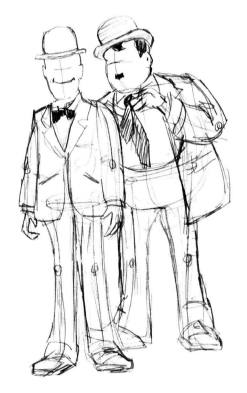

The body posture and shape help in the identification of this comedy duo, but it's their clothing and how it's worn that makes them unmistakably Laurel and Hardy.

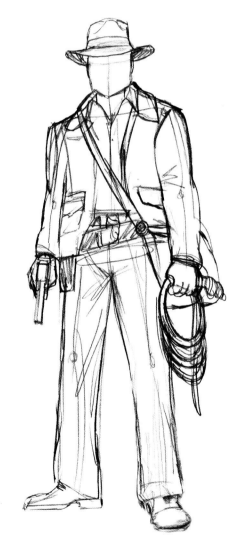

In this sketch the body and posture are unremarkable—it's the clothing and selection of props that leave no doubt that you are looking at film star Harrison Ford in character as Indiana Jones.

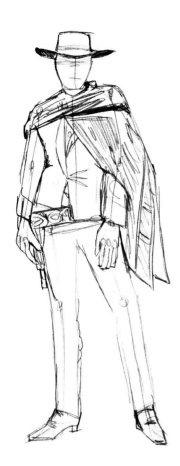

Many cowboy characters have been represented over the years, but there was only one who wore a poncho draped over his shoulder. The spaghetti Westerns gave birth to "the man with no name," played by legendary movie star and director Clint Eastwood.

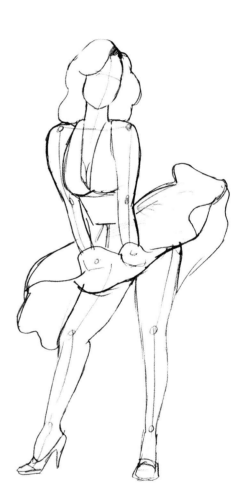

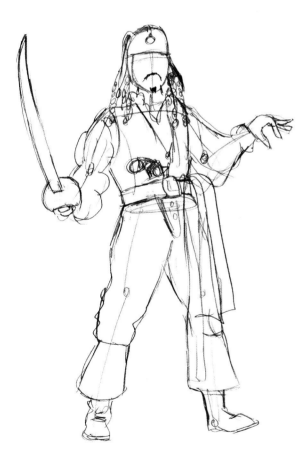

Body posture plays a big part in identifying who this celebrity is, but it's the dress and the invisible prop—the upward gust of air—that act as an instant identifier of 1960s movie star and blonde bombshell Marilyn Monroe.

I'm sure that with this array of clothing and props you'll have no problems identifying Captain Jack Sparrow, played by Johnny Depp in the *Pirates of the Caribbean* films.

These two men are both dressed in suits and holding guns. While their very different body posture helps to distinguish them from one another, it's the style of suit, boots, shirt, glasses, and hair that make the far right figure unmistakable as character Austin Powers, played by comedy actor Mike Myers. The other, of course, is Bond—James Bond.

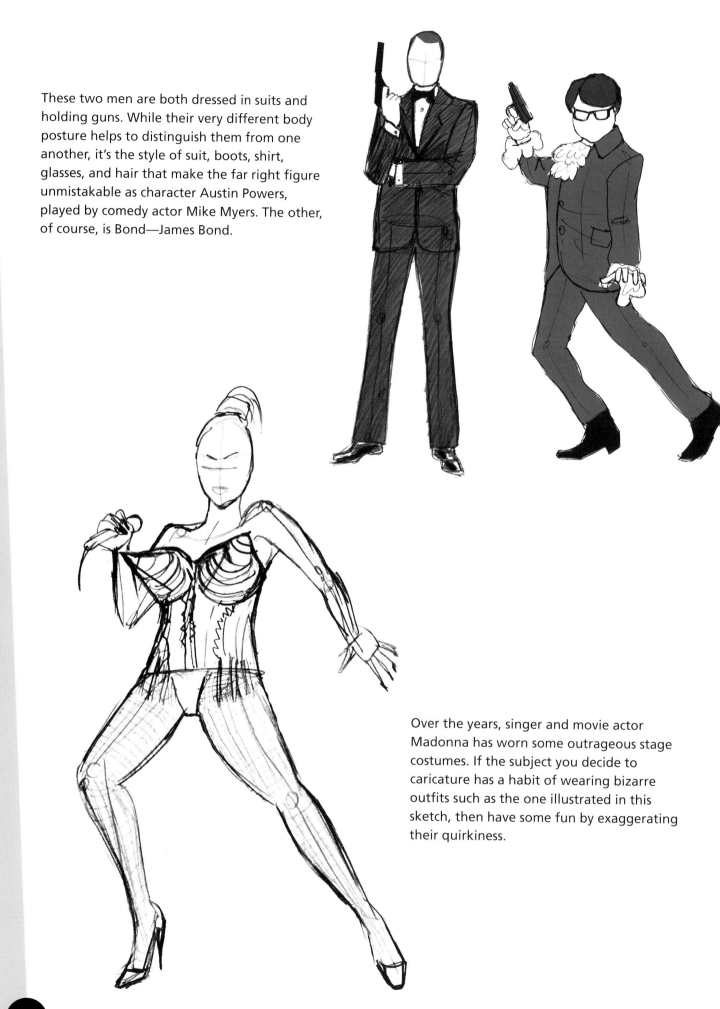

Over the years, singer and movie actor Madonna has worn some outrageous stage costumes. If the subject you decide to caricature has a habit of wearing bizarre outfits such as the one illustrated in this sketch, then have some fun by exaggerating their quirkiness.

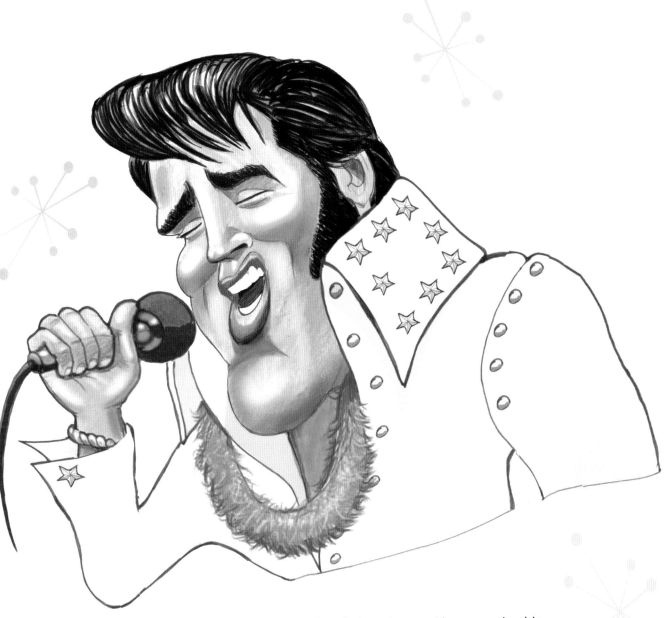

Elvis Presley, the King of Rock, is caricatured here wearing his flamboyant star-studded, high-collared stage suit. His hairstyle, unique facial features, and expression gave me plenty to work with, but to complete the caricature the right choice of props and clothing made all the difference.

# CELEBRITY COUPLE: PROPS & CLOTHING

When it comes to celebrity couples there are plenty to choose from, but unfortunately few stand the test of time. With that in mind, when it came to choosing the ideal couple for this feature, I chose a couple I believed would still be together many years hence. Who better than Sharon and Ozzy Osbourne, who have been married for nearly thirty years already?

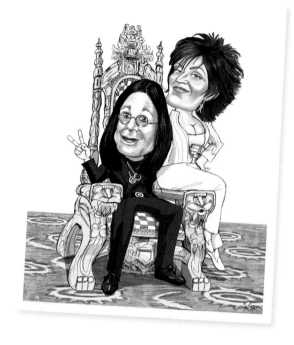

When taking on a complicated caricature that includes more than one person as well as props, it's worth spending time on some preliminary sketches. This is my first rough pencil draft. At this stage all I wanted to do was lay down the basic composition of the props and figures involved.

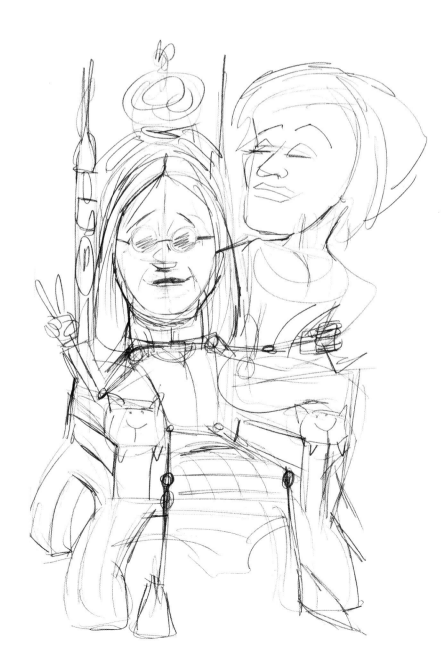

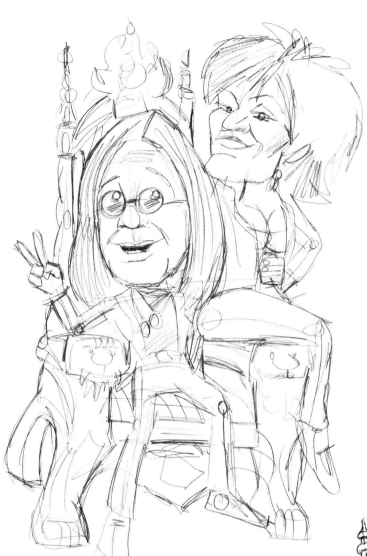

Using the previous draft as a basic layout reference I drew a second sketch, this time adding more detail to the couple's faces and clothing. Although this sketch is still quite loose it contains individual facial expressions, body postures, and gestures—the key elements for the final artwork.

One of the reference photos I used featured Ozzy sitting on a large wooden throne elaborately decorated with intricate carvings. To help me get the dimensions right, I drew the throne on its own. Details from this drawing could then be traced into my final piece.

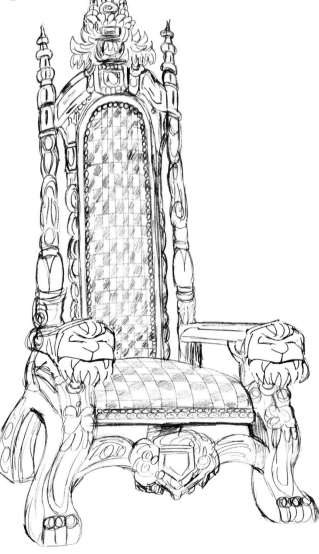

Using a light box, I traced some of the work from my previous sketches to produce this draft for my final piece. I changed a few things on the way, such as the angle of Ozzy's legs and the width of his trousers. I also altered the position of his head so that he was looking toward the viewer.

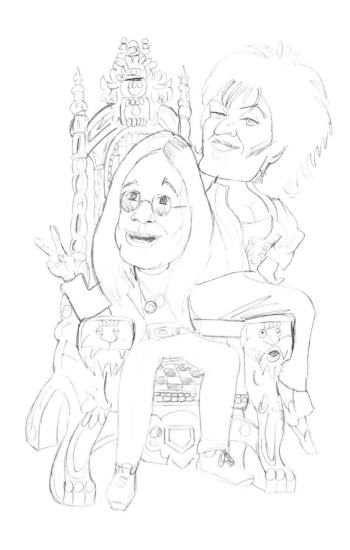

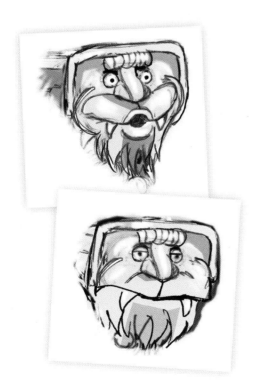

IF YOU CAN ADD A LITTLE HUMOR TO THE PROPS, SO MUCH THE BETTER. THESE ILLUSTRATIONS ARE FROM THE CARVED FACES ON THE FRONT OF THE THRONE ARMS. THEY SHOULD BE IDENTICAL, BUT I DECIDED TO CREATE A WINDED EXPRESSION ON THE ONE BENEATH SHARON—A LITTLE CHEEKY, BUT ALL IN GOOD FUN.

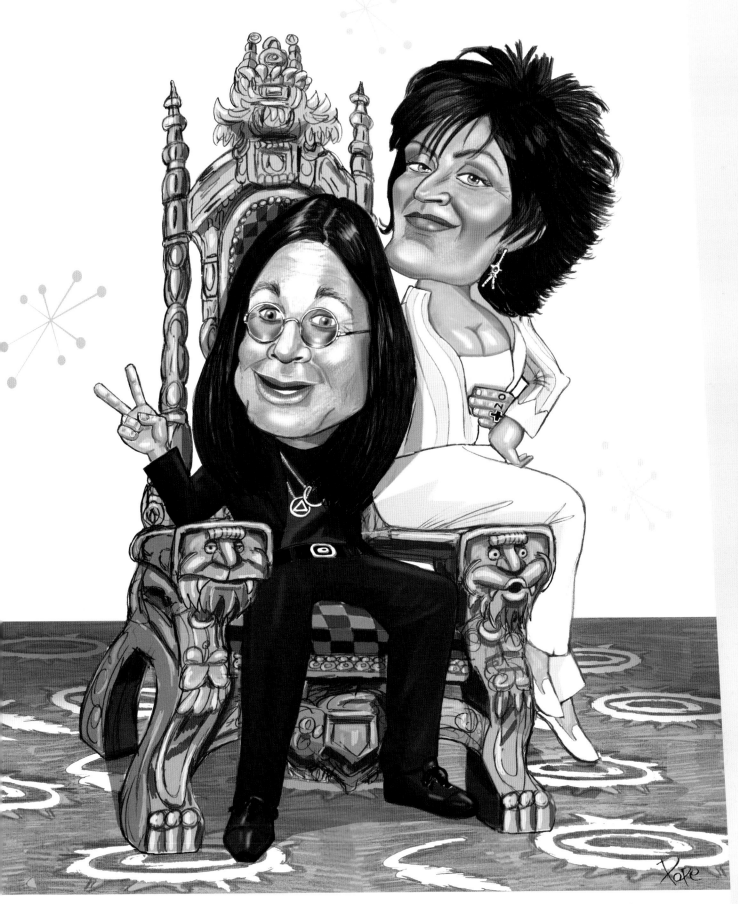

The decorative carpet and elaborate throne serve as a great backdrop for the finished piece of artwork. It's always key to capture the subjects' unique facial characteristics, but the attention paid to the overall composition along with the body postures and gestures help to make this caricature successful.

# Anthropomorphism

If you want to test your expertise and creativity as a caricaturist, anthropomorphism is a great way of doing so. To be able to represent an individual's facial characteristics on an inanimate object or a different species takes probably more skill than any other form of caricaturing. There are different variations of anthropomorphism, some a lot easier than others. The simplest is to merge the head of your subject on to the body or object that is relevant to your caricature.

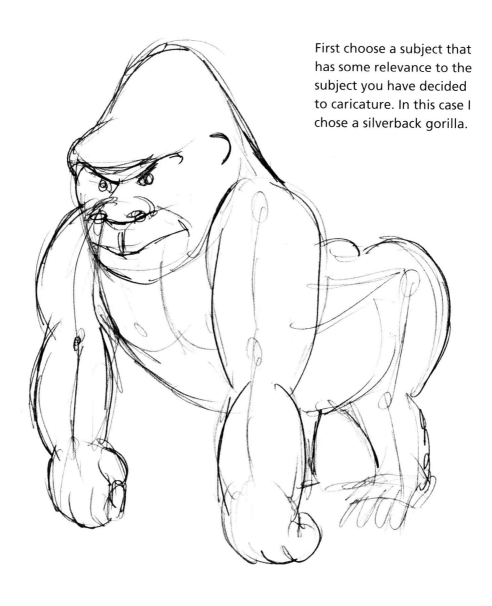

First choose a subject that has some relevance to the subject you have decided to caricature. In this case I chose a silverback gorilla.

Once happy with the proportions and posture, I erased the gorilla's head and replaced it with a caricature of my chosen subject.

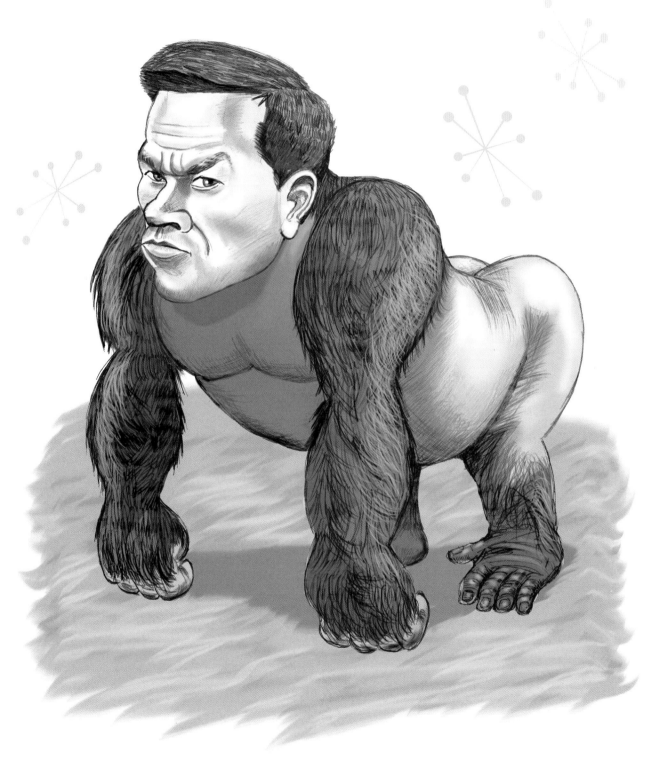

Here is my finished caricature of the movie star Mark Wahlberg portrayed as a silverback gorilla. Apart from the obvious connection of Wahlberg playing the lead role in the movie *Planet of the Apes,* his muscular physique and the deep facial frown make him an ideal celebrity for this piece of anthropomorphism.

Taking the anthropomorphism process a stage further, I chose a rhinoceros—a species that bears no resemblance at all to our own, which makes this caricature far more of a challenge than the gorilla on the previous pages.

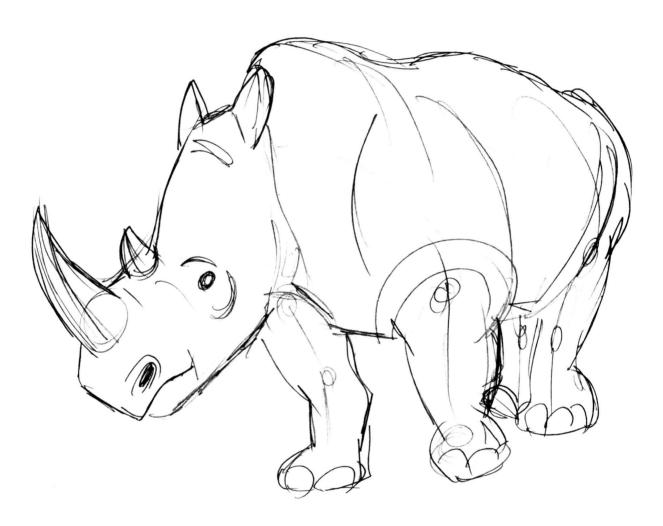

This time the shape and position of the subject's facial features would have to be drawn in such a way that they conformed to the shape of a rhinoceros head—plus I had a horn to contend with!

The next step was to choose a subject who was renowned for being incredibly strong and powerful. A young Mike Tyson would do the trick.

Before attempting an anthropomorphic caricature it's worth drawing a caricature of your subject first to make sure you have captured what is unique about them. Once you have done this you can then use the relevant elements from your preliminary caricature as reference for creating your anthropomorphic version.

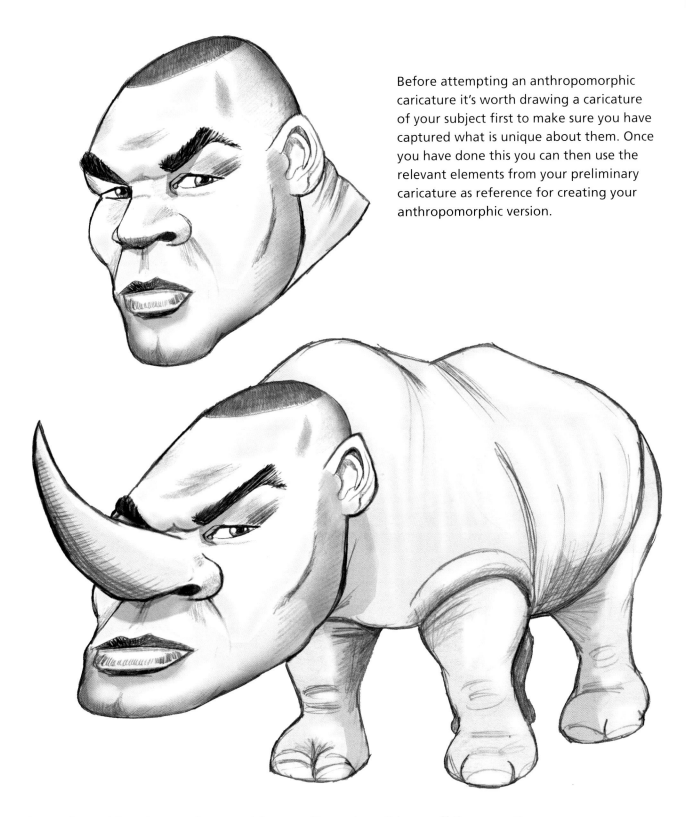

Admittedly, in this caricature the resemblance to Tyson doesn't jump off the page. However, considering that his nose has been replaced by a horn, his ears are at the top of his head, and the basic shape of the head is nothing like that of a human, to accomplish any resemblance was an achievement. If you can see a resemblance it will be down to the eyes, eyebrows, and hairstyle.

Here we have an older, heavier Mike Tyson caricatured as a hippopotamus—another strong, fierce creature, but with a very different head shape. I deliberately chose to caricature the same subject to demonstrate that it's possible to find something unique and distinguishable in your subject that will be recognized no matter what form they take.

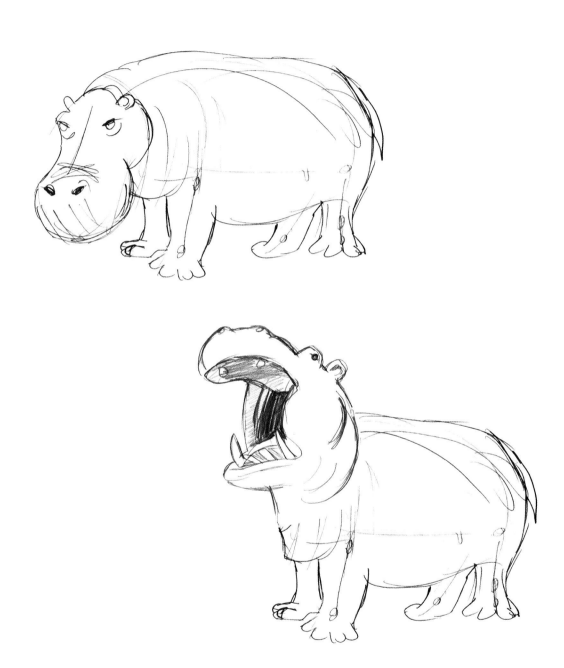

These two images were sketched from photographs I found surfing the web. The sketch immediately above is the one that I favoured, but I had to adapt the angle for the final artwork or the subject's facial features would have been hidden from view.

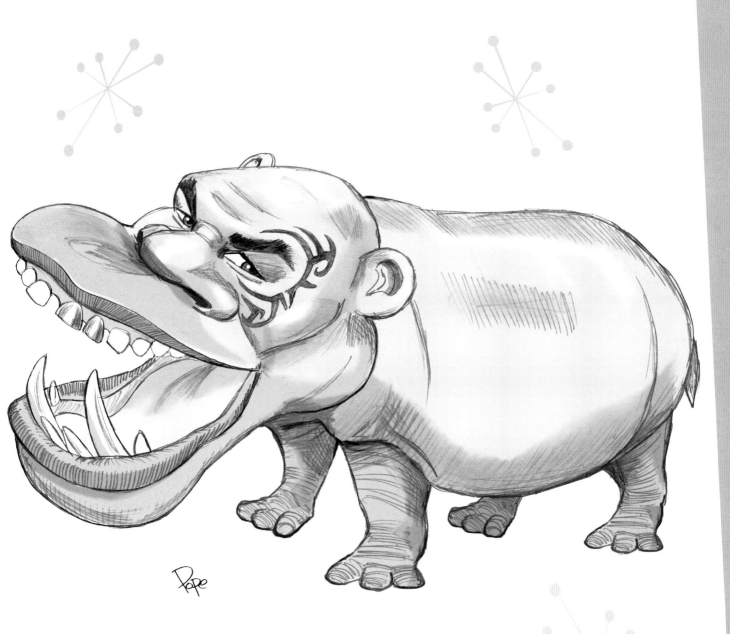

The facial tattoo, the eyes and eyebrows, and the gap between the front teeth, two of them gold, all add up to this fairly successful anthropomorphic caricature.

Anthropomorphism can be used with inanimate objects as well as animals. Means of transport such as planes, boats, and trains make great subjects to use. For this next anthropomorphic celebrity caricature I chose the movie star Nicholas Cage, who starred in the 1997 movie *Con Air*.

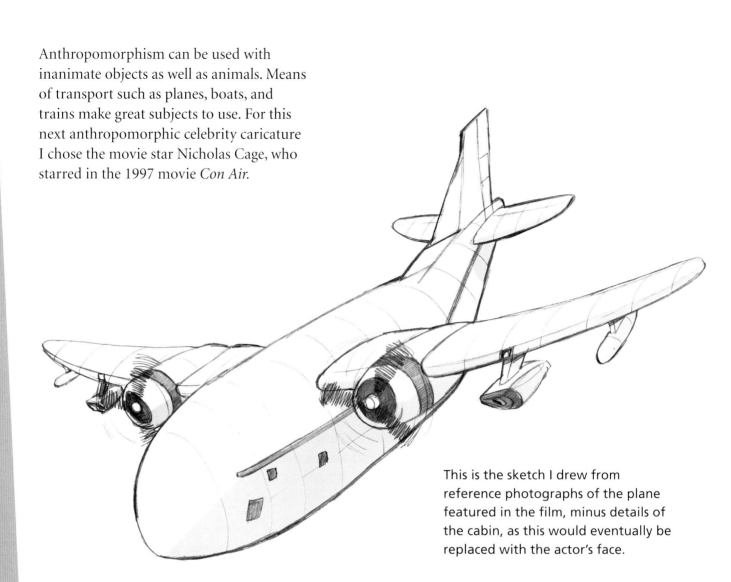

This is the sketch I drew from reference photographs of the plane featured in the film, minus details of the cabin, as this would eventually be replaced with the actor's face.

This was my first attempt at caricaturing Cage. It's not quite right, but the resemblance was good enough to make a start from. Make sure you draw your caricature at the correct angle so that when you eventually combine the two drawings they match up.

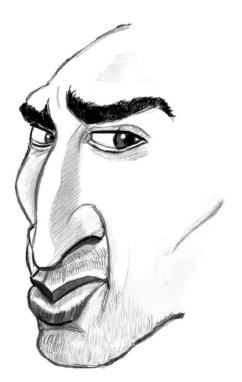

Here is the end result: movie star Nicholas Cage caricatured as the plane from *Con Air.*

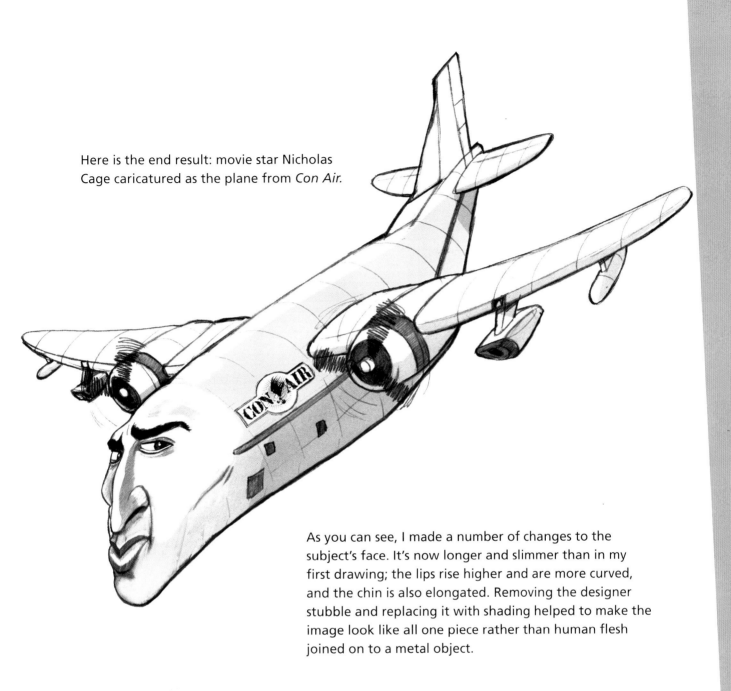

As you can see, I made a number of changes to the subject's face. It's now longer and slimmer than in my first drawing; the lips rise higher and are more curved, and the chin is also elongated. Removing the designer stubble and replacing it with shading helped to make the image look like all one piece rather than human flesh joined on to a metal object.

THE OVERALL SHAPE OF THE PLANE'S NOSE ALSO HAD TO CHANGE OR IT WOULD NEVER HAVE RESEMBLED THE ACTOR. WITH THIS TYPE OF CARICATURE YOU NEED TO MAKE A COMPROMISE BETWEEN ONE SUBJECT AND THE OTHER UNTIL YOU REACH A SUCCESSFUL MIDDLE GROUND. IT CAN BE DIFFICULT AND A LOT OF TRIAL AND ERROR MAY BE INVOLVED, BUT WITH PRACTICE IT BECOMES EASIER.

# Caricature Extremes

Certain celebrities have something about their character or facial features that begs you to caricature them to the extreme. It's possible to do this with any subject, but I am usually most tempted when either their personalities or their features are larger than life.

Television personality and talent-show judge Simon Cowell was an ideal candidate for this type of caricature. Although none of his features is particularly large or unusual, his on-screen character and temperament certainly are.

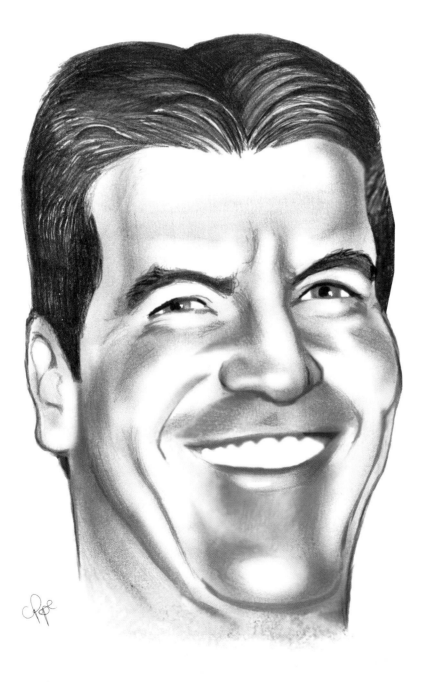

The above portrait is a good likeness of the reference photograph used by the artist. I used this photograph along with many others as reference.

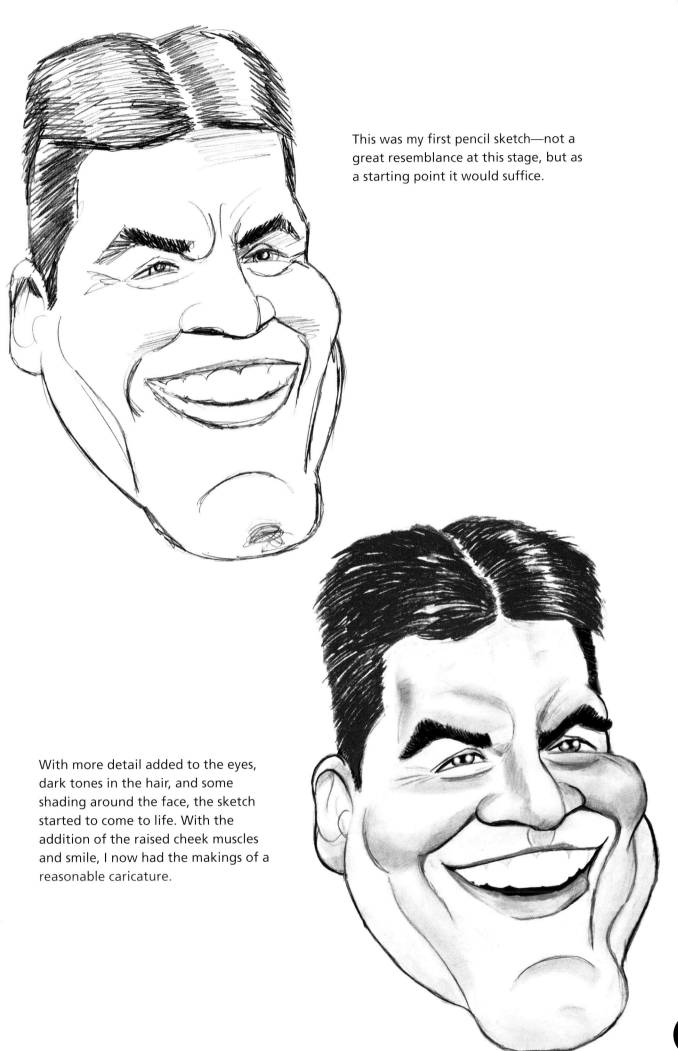

This was my first pencil sketch—not a great resemblance at this stage, but as a starting point it would suffice.

With more detail added to the eyes, dark tones in the hair, and some shading around the face, the sketch started to come to life. With the addition of the raised cheek muscles and smile, I now had the makings of a reasonable caricature.

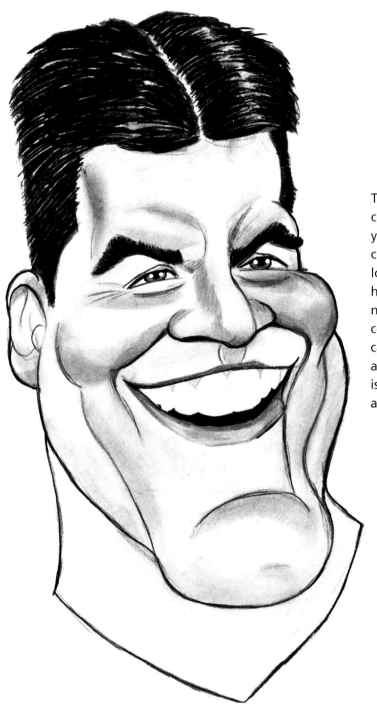

This is the stage at which the caricature became extreme. As you can see, I have made the chin considerably larger and longer. Although Simon does not have a high forehead, I felt the need to increase the height to counterbalance the chin. With caricaturing there is always a fair amount of trial and error, but this is even more the case when you are aiming for the extreme.

TELEVISION CELEBRITIES ARE OFTEN HEAVILY MADE-UP FOR THEIR SCREEN APPEARANCES AND YOU MAY WANT TO MAKE A POINT OF EXAGGERATING THIS: HAIR GEL, EYE MAKEUP, AND UNUSUAL SKIN TONE ARE ALL THINGS TO LOOK OUT FOR.

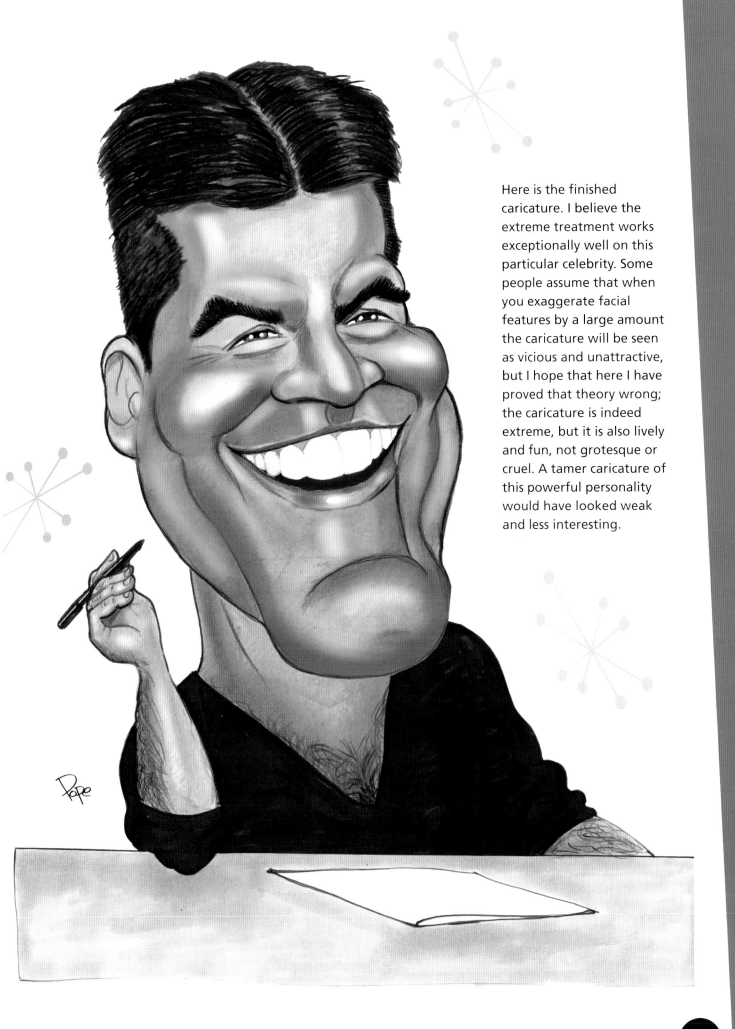

Here is the finished caricature. I believe the extreme treatment works exceptionally well on this particular celebrity. Some people assume that when you exaggerate facial features by a large amount the caricature will be seen as vicious and unattractive, but I hope that here I have proved that theory wrong; the caricature is indeed extreme, but it is also lively and fun, not grotesque or cruel. A tamer caricature of this powerful personality would have looked weak and less interesting.

# Different Styles & Techniques

Caricatures can be approached in many styles and using a whole range of materials, and this choice makes the craft all the more interesting. Some caricaturists make incredibly detailed drawings or paintings; others get down a likeness in just a few marks—and both techniques can yield great results. It is a good idea to experiment with different styles and see which suits you best.

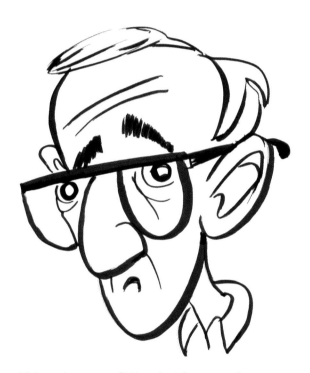

The brush-tipped pen is popular with caricaturists at live events as it's flexible and ideal to use at speed. The thickness of the line is determined by the angle at which you hold the pen and how much pressure you apply.

This caricature of Woody Allen was drawn using only a few lines of a brush pen, with no shading or rendering. It's very different from my usual style and I was only able to draw it successfully by studying the work of other illustrators and caricaturists. To capture a likeness with so few lines is no easy task.

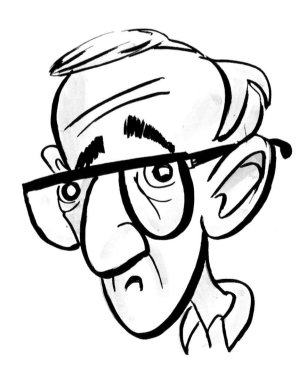

Here is the same artwork with some added dabs of tone from a light gray marker pen. It's still a very simple drawing, but it has gained a little more depth.

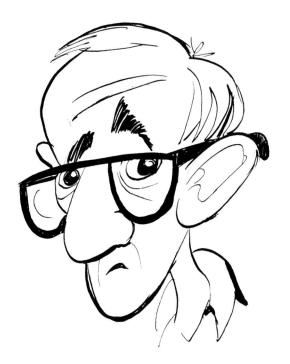

This sketch was drawn with a Gillot drawing pen and black India ink. Again the thickness of line is determined by the angle and pressure applied, but as you can see the lines are much finer and more detailed than those from the brush pen, and they can be drawn thinly enough to produce excellent crosshatching. Using this type of pen achieves an authentic scratchy look quite different from any other medium.

India ink has a superb dark, dense quality. However, it can be a little frustrating as it takes a while to dry, so you need to be extra careful not to smudge your artwork.

Once it is dry you can add tone with a brush, using a lighter shade of ink or watercolors.

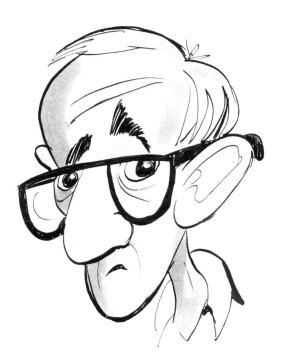

# ONE SUBJECT, THREE STYLES

I was inspired to draw this caricature of Madonna in a rather unusual style after seeing some of the superb artwork produced by the extremely talented Argentinian artist Pablo Labato. I certainly wouldn't have been able to achieve a likeness in this style without studying some of Labato's work first.

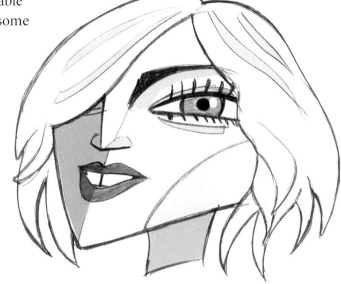

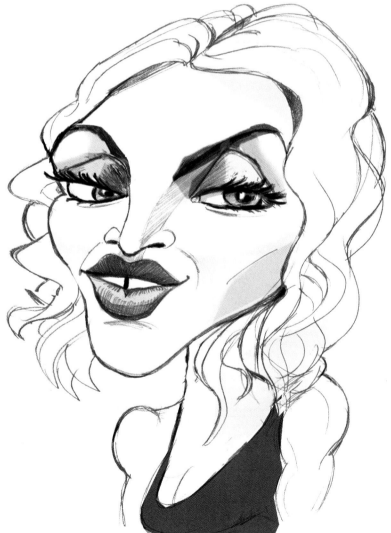

This is another caricature of Madonna, again done in a different style to how I would normally draw. It looks completely different from the artwork above, yet both images are recognizable as Madonna.

The examples on these pages show just a few of the many different styles of caricaturing. As a beginner it's well worth experimenting with various styles to see which you feel most comfortable with.

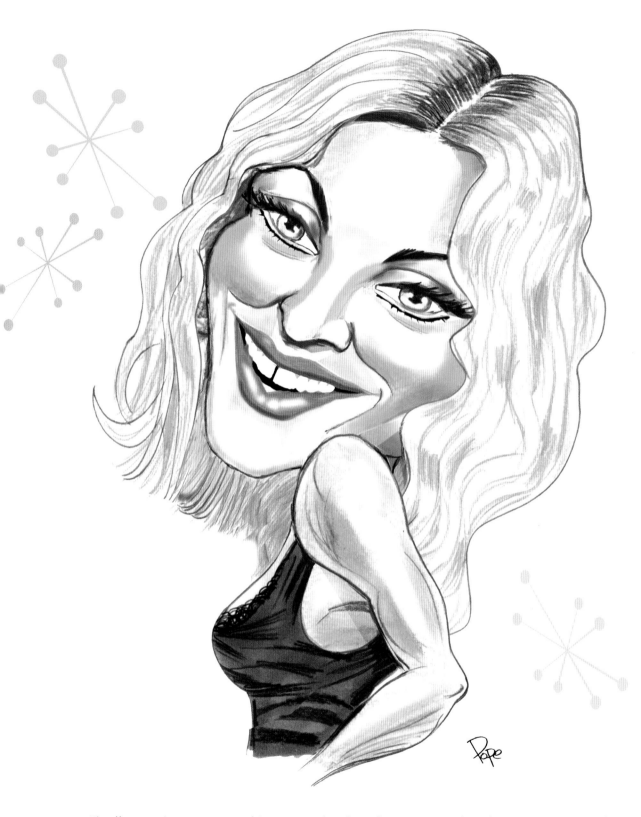

Finally, a caricature created in my usual style. When compared to the two images on the facing page, it almost looks like a straight portrait. In fact I have exaggerated certain facial features and if you look at a photograph of Madonna you'll see that the artwork is, without doubt, a caricature—albeit a relatively tame one. All three images show completely different interpretations of the same subject.

# Color Rendering

Unlike the simple line caricatures on the previous pages, the caricature artwork featured here required the addition of tone and shading to bring it to life. My initial caricature of the actor Hugh Laurie— in character as House from the TV series of the same name—was drawn using a black polychromos artists' pencil. The tone was added using computer software after scanning the image (see pages 116– 121 for more on computer techniques), but it could have been done just as effectively by using a light gray marker pen.

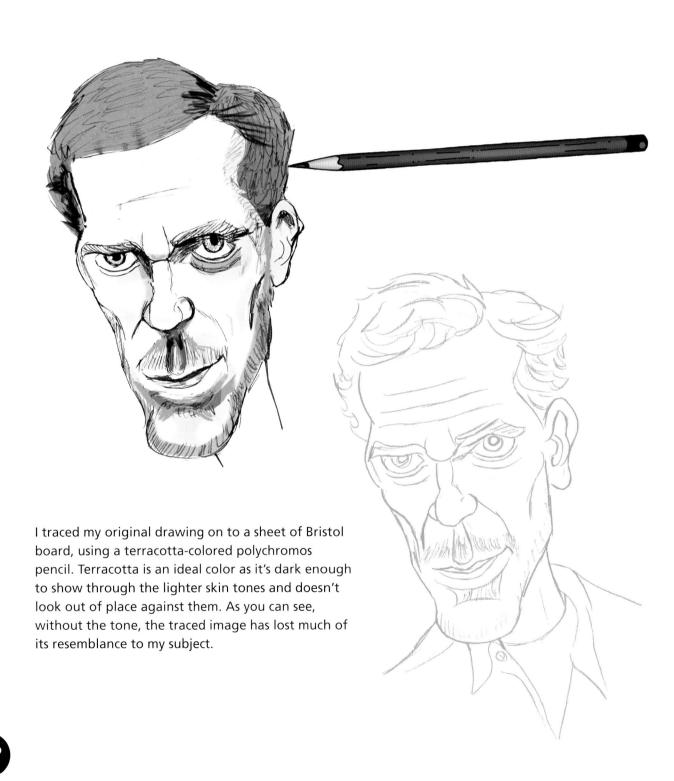

I traced my original drawing on to a sheet of Bristol board, using a terracotta-colored polychromos pencil. Terracotta is an ideal color as it's dark enough to show through the lighter skin tones and doesn't look out of place against them. As you can see, without the tone, the traced image has lost much of its resemblance to my subject.

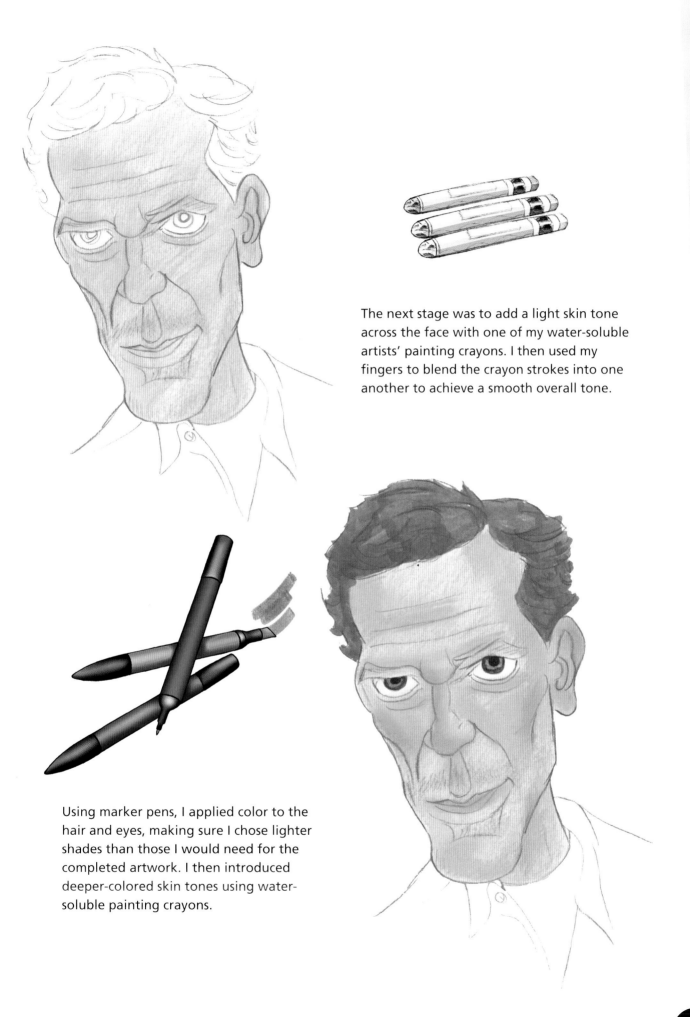

The next stage was to add a light skin tone across the face with one of my water-soluble artists' painting crayons. I then used my fingers to blend the crayon strokes into one another to achieve a smooth overall tone.

Using marker pens, I applied color to the hair and eyes, making sure I chose lighter shades than those I would need for the completed artwork. I then introduced deeper-colored skin tones using water-soluble painting crayons.

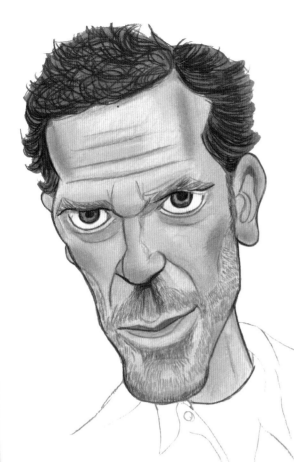

Now it was time to make use of the polychromos artists' pencils again, adding definition to the hair, eyebrows, designer stubble, and facial features. It was at this point my artwork began to show a good likeness to our character once again.

I blocked in the clothing using colored marker pens and drew around the outline using a 0.4 black fineliner pen. I then removed any smudging around the edges with a soft eraser. The caricature was now very close to completion.

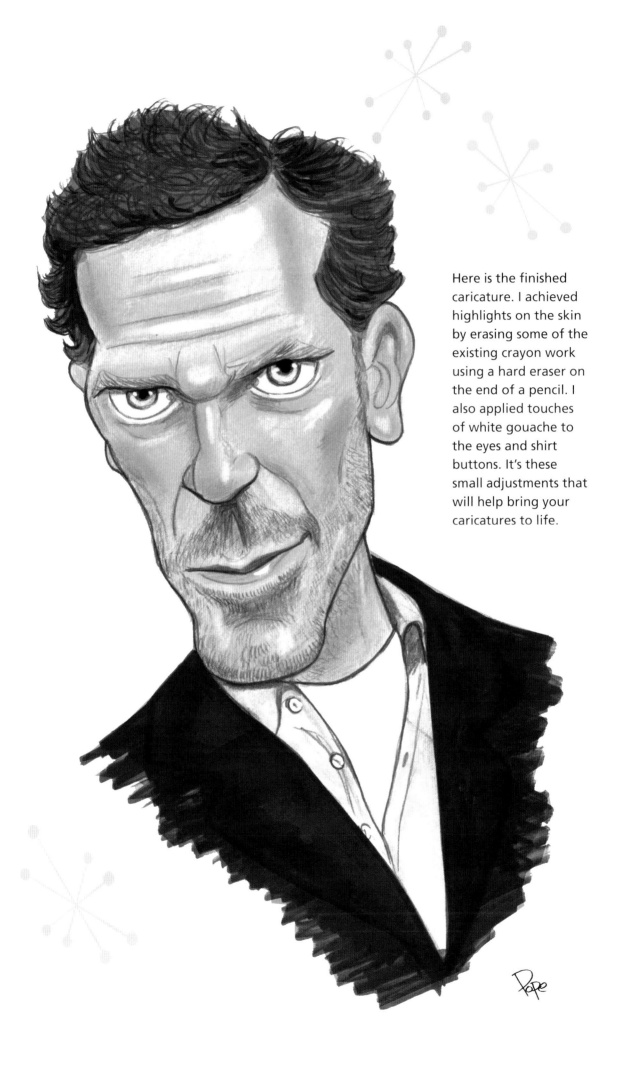

Here is the finished caricature. I achieved highlights on the skin by erasing some of the existing crayon work using a hard eraser on the end of a pencil. I also applied touches of white gouache to the eyes and shirt buttons. It's these small adjustments that will help bring your caricatures to life.

# Using Computer Technology

Computer software offers artists a variety of tools to choose from, so I have embraced this new technology in my own work. Just like traditional tools, the software requires quite a bit of skill to use effectively, so be prepared to practice and have plenty of patience. Because there are so many different software programs available, here I will only cover the tools and techniques I find most useful.

One of the most important pieces of equipment you will need is a scanner. If you can afford it, buy an 11" x 17" scanner, as this will allow you to scan larger artwork. They can be rather expensive, but if you shop around you can find them for about twice the price of a decent quality 8½" x 11" scanner. To me they are well worth the extra investment.

A graphics tablet will allow you much finer control with your drawing tool than you will be able to manage using a mouse, so I strongly recommend you buy one. Nowadays you can pick these up relatively cheaply.

Most Photoshop® software will have a range of brushes that enable you to draw with various media effects such as charcoal, pencil, watercolor, marker pen, airbrush, and so on. With the aid of a graphics tablet it's possible to originate a digital drawing without going near a pencil and paper, but I prefer to use traditional methods and only turn to computer software to enhance my work.

## BLENDING SKIN TONE

The image on the right is a detail from my Hugh Laurie caricature. All the rendering has been done to my satisfaction using traditional methods (see pages 112–115), but here I will make changes to the artwork using various software tools to illustrate their effects.

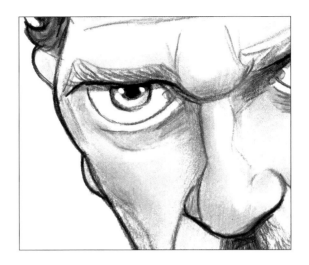

If you feel that some of your original crayon or pencil lines look a little too coarse, it's possible to soften them with the blend tool. Look closely at this detail and you will see that the lines beneath the eye and over the cheek have been blended together to create a more even tone.

In the Photoshop toolbox, the icon shaped like a raindrop is the blend tool.

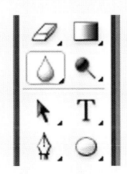

## ADDING TONE

To add extra shade or color to a particular area of your artwork, use the lasso tool in polygon mode to select the area you want. In Photoshop, the polygonal lasso tool can be found by clicking on the freehand lasso tool, which has an icon like a noose. Using your graphics pen or mouse, click around the area until it is fully encompassed by a shimmering dotted line.

Here is the icon for the polygonal lasso tool.

The paintbrush icon is immediately recognizable.

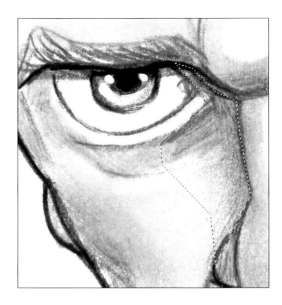

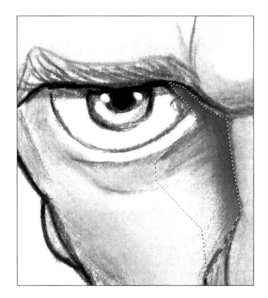

There are various choices of paintbrush in Photoshop, and here I chose the spray can option. In most software programs you can alter the size of the brush, as well as opacity and flow. In Photoshop, spray the area you wish to cover, choose Select at the top menu bar then Deselect from the drop-down menu; the dotted line will then disappear.

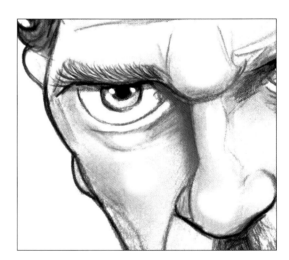

With this image I used the same brush but altered the color to add extra highlights to the flesh areas beneath the eye and above the nose. I then reduced the size of the brush to a very small 6px, adjusted the flow to 100%, and applied detailed strands of hair to the eyebrow.

## CREATING A GRADUATED BACKGROUND

To create a sky-effect background for an artwork, first click on the magic wand icon highlighted second from the top on the right-hand side of the toolbox, and then click anywhere in the area you require to be sky. A shimmering dotted line will encompass your image and the four sides of the drawing area. Note the tolerance setting (highlighted third from left at the top) that affects the accuracy of the selection; if you want a sharp image choose a high tolerance, but if you are working in a more sketchy fashion go for a lower setting.

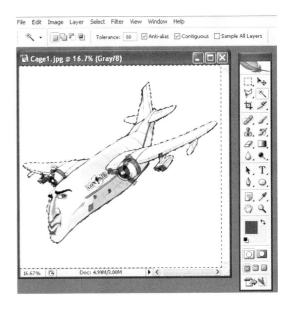

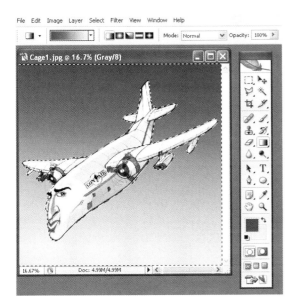

Choose the gradient icon highlighted sixth from the top on the right. Click and keep pressed at the top of the image then drag downwards. The area minus the image in the center will then fill with a graduated tone. The icon fourth from the bottom, where one square overlaps the other, shows the two colors I chose to graduate together.

Finally, under the Select menu at the top of the screen, choose Deselect. The shimmering lines will disappear and you'll be left with an excellent sky effect.

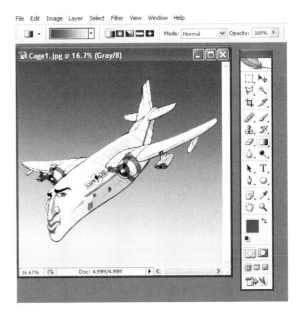

## MANIPULATING IMAGES

Sometimes you may look at a finished caricature and think that if only you had drawn a certain feature a little differently the end result would be much better. Fortunately, there are tools that allow you to transform what you have already drawn.

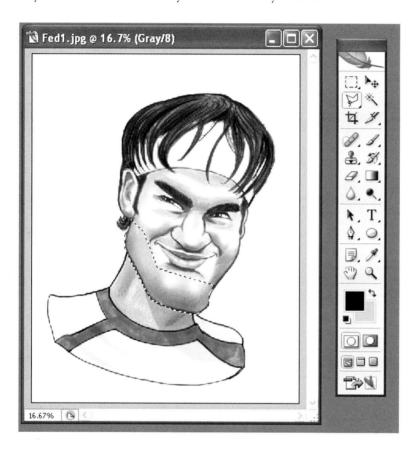

My favorite transform tool is the warp option, which allows you to make adjustments in size and shape to any part of your artwork. Use the polygonal lasso tool to encompass the area you wish to alter by clicking around it. Once it is fully encompassed a shimmering dotted line will appear as before.

Go to Edit in your top menu bar, and in the drop-down menu choose Transform, and then Warp.

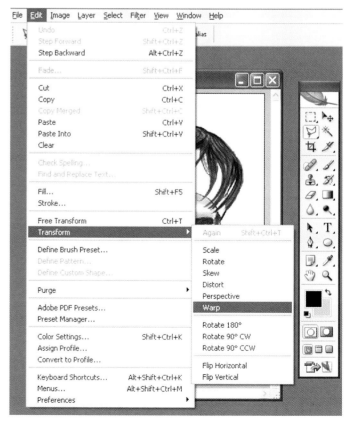

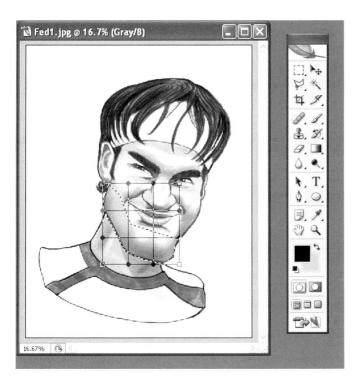

A grid with dots on the corners of each of the squares will appear around the area you marked.

Using your cursor, choose a dot closest to the area you wish to manipulate, and then drag it in the direction you wish to increase or decrease. Once you are happy with the look of your artwork, click on one of the icons from the right-hand toolbox to deactivate the grid, and then save your image.

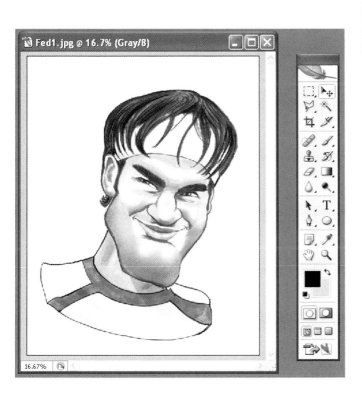

The chin is now far too big and the caricature looks less like Roger Federer than it did previously, but you can see the warp tool's potential. Try to use it only on a limited basis—your drawing skills will not advance if you become too reliant upon it.

# Caricaturing from Life

There's a huge difference between drawing from life and drawing from a photograph. While you can study a photograph at leisure, a live subject can shift position, change expression, become nervous or impatient, and so on. When you draw from life, especially if you are being paid for it, you need to draw at a faster pace and be more decisive with the lines you draw. Before you begin, spend a minute just looking at your subject, thinking about how you are going to approach the caricature and which of their features you are going to exaggerate. To start with, you can use a pencil or a light gray brush pen to work out a rough framework, but aim to do away with this process eventually: in general the lines you put down stay down.

When you draw from life you need to learn not to be too much of a perfectionist, otherwise you will never relax enough to be able to improve. Taking great pride in getting the best likeness you can is fine if you are keen to get into the world of published caricatures, but if you want to draw from life you have to accept that some of your work will turn out well below the standard you want. However, as a very talented live caricaturist once pointed out to me, the person whom you are drawing is unlikely to possess any caricaturing talent at all and will probably be impressed by whatever you present them with, so try to relax and let the drawing flow.

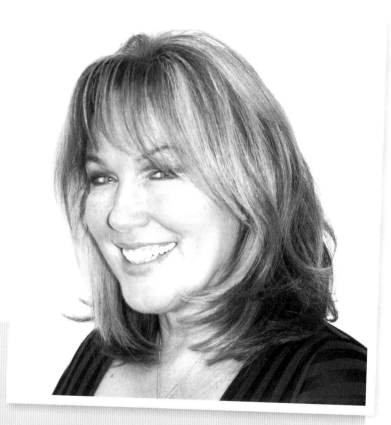

Before I started my caricature from life I took this photograph of my model from the angle I decided to draw her from so that you have something to compare the finished artwork with. Note that it's from the preferred three-quarter angle.

WHEN I FIRST STARTED DRAWING CARICATURES FROM LIFE I CHOSE PEOPLE I KNEW PERSONALLY. THEY WOULD OFTEN COMMENT ON HOW SERIOUS I LOOKED AND HOW I FROWNED CONTINUALLY. THIS IS NOT THE BEST WAY TO PUT YOUR MODEL AT EASE, SO MAKE SURE YOU SMILE AND TRY TO MAKE JOVIAL CONVERSATION. THIS WILL RELAX YOUR MODEL AND HOPEFULLY TEMPT A SMILE OUT OF THEM.

Using a black brush pen, I started at the top of the head and worked down, laying out the contours of the face. Some caricaturists prefer to start with the eyes, nose, and mouth, although the trouble with this method is that you can find yourself running out of space.

The next stage of my caricature was to draw the eyes, nose, and overall shape of the mouth. People don't smile for long, so it's important to get the basic shape down as soon as you can.

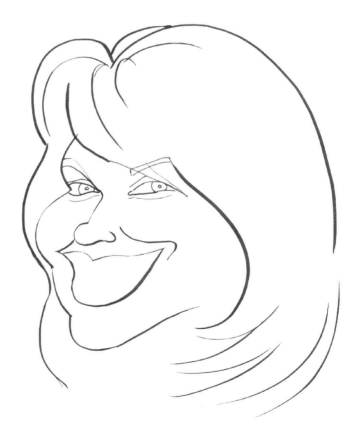

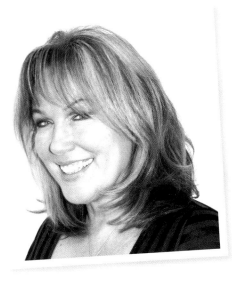

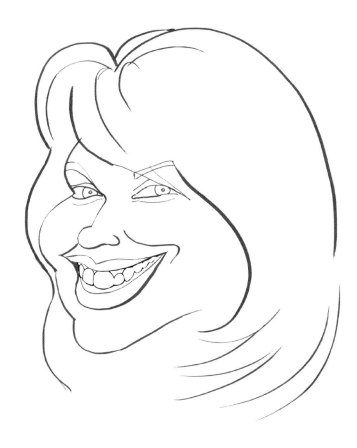

Next I drew the lips, being careful not to apply too much pressure to my brush pen as I needed to keep the lines relatively thin. I then drew in the teeth using a fineliner pen.

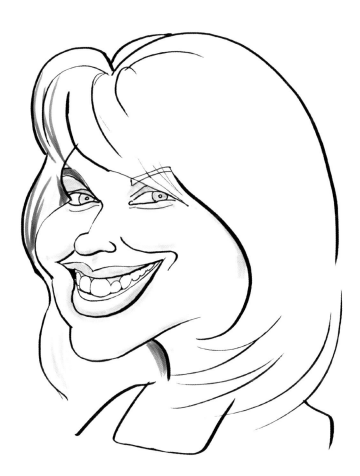

The next stage was to introduce some shading on the lips, cheekbones, eyes, and hair. For this I used two more brush pens, a light and medium gray.

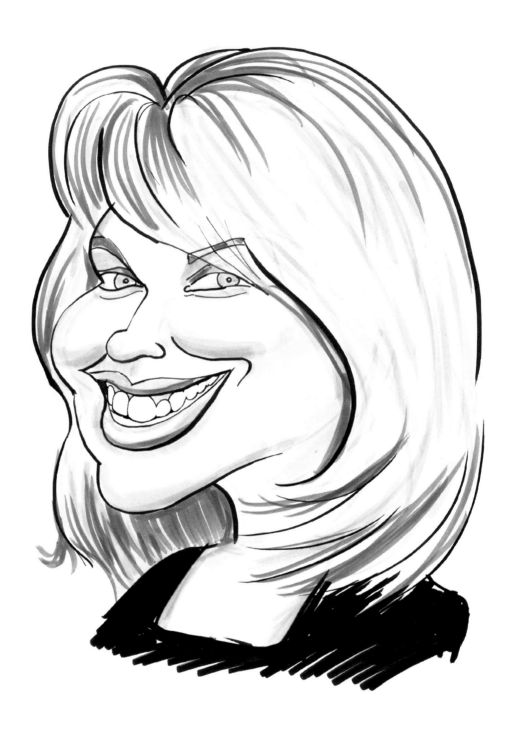

Using the black brush pen, I blocked in the top my model was wearing. I also added more overall tone to the flesh, hair, and eyes, using all three brush pens. I was careful not to over-use the tone and lose the effect of light reflecting off the face and hair. At this point my caricature was starting to come to life and look more three-dimensional.

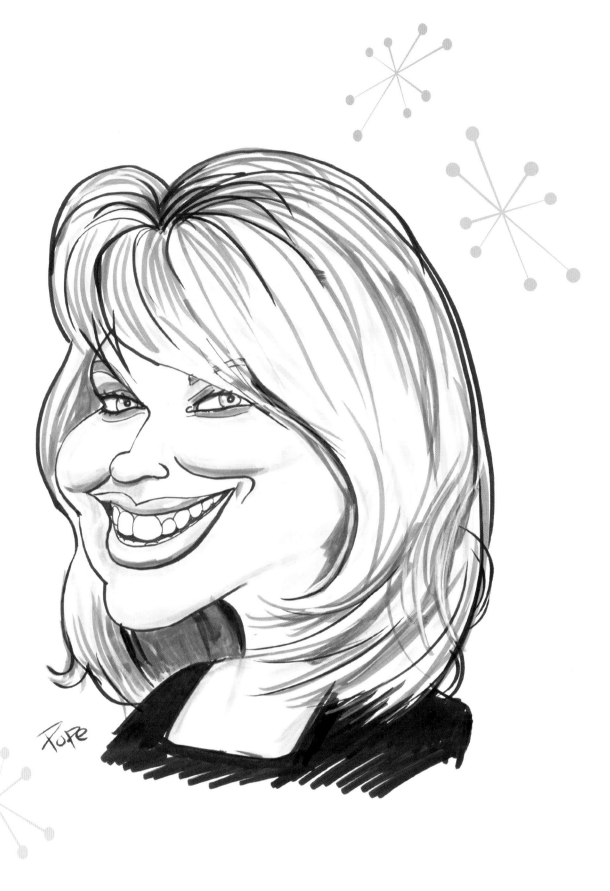

This is the finished caricature. I used a little more tone and added some eyelashes with a fineliner pen. I also used a Tipp-Ex pen to add some highlights to the eyes, lips, and hair and touch up the teeth. It's not the best caricature I've drawn, but it only took about six minutes. Therefore, I'm reasonably happy with it—and luckily so was the model.

# About the Author

MARTIN POPE WAS BORN IN SINGAPORE IN 1958 AND HAS LIVED IN THE UK SINCE 1966. ALWAYS ARTISTICALLY CREATIVE, HE STARTED DRAWING RECOGNIZABLE CARICATURES FROM THE AGE OF TWELVE. NOW HE IS AN ESTABLISHED FREELANCE ILLUSTRATOR, RECEIVING REGULAR COMMISSIONS FROM LARGE CORPORATIONS SUCH AS JP MORGAN, SONY, AND THE ROYAL BANK OF SCOTLAND, AS WELL AS IN-HOUSE AND NATIONAL MAGAZINES. DRAWING CARICATURES REMAINS HIS MAIN LOVE AND OCCUPATION.

FOR MORE INFORMATION ABOUT MARTIN POPE'S WORK, VISIT WWW.MARTINPOPE.CO.UK.